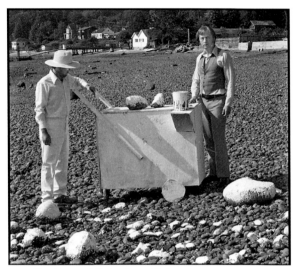

Jim Holl and Steven Holl, Manchester, Washington, 1976.
Photo: William Vanderbilt.

DEDICATED TO
Helen Mae Holl

Jim Holl
The Landscape Painter

AN AUTOBIOGRAPHY 1974 THROUGH 1994

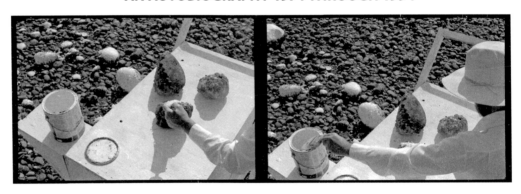

CHARTA

Design
James Holl Design
www.jimholl.com

Photography
Cover and title page photos: Steven Holl
Manchester, Washington. 1976
Back cover photo: Jim Holl
Icicle Creek, Olympic Mountains, 1977
All photography Susan Wides unless
otherwise credited.

We apologize if, due to reasons wholly beyond our
control, some of the photo sources have not
been listed.

Design Coordination
Daniela Meda, Gabriele Nason
Editorial Coordination
Filomena Moscatelli
Copyediting
Emily Ligniti
Copywriting and Press Office
Silvia Palombi
US Editorial Director
Francesca Sorace
Promotion and Web
Monica D'Emidio
Distribution
Antonia De Besi
Administration
Grazia De Giosa
Warehouse and Outlet
Roberto Curiale

2009 Edizioni Charta, Milano
©Jim Holl for his works and texts
All rights reserved
ISBN 978-88-81-8158-729-2
Printed in Italy

Edizioni Charta srl
Milano
via della Moscova, 27-20121
Tel. +39-026598098/026598200
Fax +39-026598577
e-mail: charta@chartaartbooks.it

Charta Books Ltd.
New York City
Tribeca Office
Tel. +1-313-406-8468
e-mail: international@chartaartbooks.it
www.chartaartbooks.it

contents

foreword

This book is intended for students of art. It recounts my efforts to come to terms, to understand through art, the dichotomy between thinking and feeling, art and life, artifice and authenticity. I came of age in the mid-1970s. At that time the course of modern art had been, depending on the date chosen, evolving for more than a hundred years. By the beginning of the 1970s in some quarters modern art had been declared as having reached its apotheosis. I came to consider art making with this dialogue in mind, and by these theories my artistic decisions were influenced. In this essay I have referenced and credited many of the writers who have examined the course of modernism and the subsequent post-modern era. I invite the reader to go to the sources, those who have written extensively about the demise of modernism and the advent of post modernism for their theoretical insight. I write this memoir as I make art, from a personal point of view. This essay tells the story of my development and reflections in relation to the backdrop of the events and theories that I experienced when I came from Seattle to live and work in New York City between 1974 and 1994. Herein I show my journey in art and life, in word and deed.

To make art is to be engaged in a dialogue with oneself. Life may require one's application to many services but to make art is always to apply to one's self-realization. I recommend to my students that this dialogue cannot be taken away by anyone or any event. Making art is a process that gives oneself meaning. The artist engaged in the process of self-discovery is at the beginning of the story of modern art. Art may address the self, culture, or history, but it cannot be done alone. If art isn't communicated it's stillborn.

I have had the honor of a coterie of confidants to share in the dialogue of art. The artist Susan Wides has been my partner in life and art for nearly thirty years. I am grateful for her influence and support. In addition this project could not have been realized without the support of Gail Wides, Steven Holl, and Solange Fabião.

JIM HOLL, OCTOBER 25, 2008

THE LANDSCAPE PAINTER

What are artists to do in an age with few credible compass points?
The matter besets serious artists of all kinds.

Stanley Kauffman [1]

Art in art is art.
The end of art is art as art.
The end of art is not the end.

Ad Reinhard [2]

HOW I CAME TO TOWN

I left Seattle before the technological boom brought economic and cultural credibility to the northwest. I had spent 1974 in a cabin on the shores of Puget Sound, and it was there that I decided I wasn't going to be a provincial artist. At that time New York City was the center of the art world and SoHo was the downtown district where artists wanted to be. Just before I got on the Greyhound bus, I heard a nearby phone booth ring. On a whim I answered the call, it was a local radio station. The DJ wanted to know what was happening at the bus station, suddenly I was on the air. I said my farewell to all of Seattle. That, I thought, was good luck. With five hundred dollars in my pocket, I stepped off the Greyhound onto Times Square, looked up at the tall buildings, and made my way downtown.

In the 1970s SoHo was in the midst of a transformation. A former manufacturing center, its nineteenth-century cast iron buildings and cobblestone streets were becoming artists' studios. In the days before Internet, postings for rooms to rent and all else local could be found on the bulletin board at the neighborhood bar. I found housing in a large loft at 64 Wooster Street where a group of artists lived. Unfortunately, my allotted space was next to the bathroom, and only a curtain separated my pillow from the bowel. After the first morning I went back to the bar to look for another loft posting.

The next try for housing was an artist's loft, which had once been a pickle factory, a rather small pickle factory, with windows facing the street at one end. I was offered to rent a room in the windowless back of the loft. The room had been the old, cold storage vault for the pickles. The floor, ceiling, and walls were all cement with one light bulb at the center. The artist welcomed and escorted me to my cell and said she was going out for the evening; she asked me if I would take care of her dog. I spent the night lying on the cement floor with my suitcase as a pillow, listening to the yappy dog's echo bounce off the walls. She returned the next morning and I went back to the bar.

When I arrived in New York City, there were just a few galleries in SoHo. Two of the pioneers were Castelli and Sonnabend. There were few shops and restaurants. There was a hardware store and a couple of diners in the neighborhood that served breakfast to workers. One morning I joined the workers, hunched over a plate of eggs and the want ads while I looked for a job. I was down to my last fifty dollars, so I asked the fellow next to me if he knew anyone who could give me a job. His name was Jack, and he had a rags-to-riches story. He had just finished remodeling the building he owned across the street. He lived in the penthouse and soon after I became the new janitor. That gave me a foothold in the city. Eventually, I was able to rent a loft on Broome and West Broadway, right above an Italian butcher. You

could visit his shop to pick out a live chicken and watch him chop its head off. Berenice Abbott took a photo of this shop in the 1930s and it looked exactly the same in 1975. Of course, now it has all changed. Upscale stores and restaurants have replaced all the dives, the manufacturing, and most of the artists and galleries. Today, SoHo is a haven for shoppers and tourists. With few to miss him, Jack the slumlord is long gone. My next job was at an art store that had opened across the street from Jack's building. Delivering art supplies wasn't a bad job. Since I was paid by the hour, I didn't mind being stuck in traffic. At each delivery, I met artists, including such luminaries as Arman, Adolf Gotelieb, Larry Poons, Ron Gorchov, David Reed, and Mark DiSuvero. And they all seemed established and successful. This gave me hope and inspiration.

HOW MY BROTHER CAME TO TOWN

Steven had finished his architectural studies at the Architectural Association in London in 1977. He came to New York for a visit on New Year's in 1978 and never used the ticket to return to his apartment in San Francisco. At that time, home was a pre-war apartment on 103rd and Amsterdam Avenue. An ancient symbol for good luck was inlaid in each corner of the living room parquet floor. That's how I knew it was pre-war. The swastikas also indicated that the apartment hadn't been renovated. The neighborhood was as worn out as the apartment. It was a neighborhood trying not to be like the ghetto alongside it. I lived there during the 1977 blackout riots. One morning, I remember getting into the elevator and seeing bullet holes in the back wall. "Late last night, a guy got shot, the doors opened up, and bam bam bam," a fellow passenger told me. From then on, when the elevator doors opened, I stood to the side. That apartment was big, so I rented out three bedrooms to college students and took the maid's room for myself. This was a very tiny room, large enough for only a bed. Although it had its own bathroom with a half bathtub, you needed to crunch up in order to use it. I built a bed up close to the ceiling giving me more floor space. Knowing that my brother was coming to visit, I found a three-legged cot that someone had thrown out and put that underneath my high bed. So, we had bunk beds just like when we were kids, except his bed drooped at one corner. For many months, we split the sixty-dollar a month rent for that little room. Columbia University provided me with a studio on 125th Street in Harlem. During that time Steven bunked with me, and I gave him a table in my art studio. This is where he began his architecture practice. While he was there, he came up with a project to span the Harlem River with a construction he called the Gymnasium Bridge. Many years later, I saw that drawing again in the architecture collection at the Museum of Modern Art. In order to put basketball courts on a bridge, the building he proposed would have required the courts to be narrowed and extended. I thought this was rather odd.

After graduation, we moved to a railroad flat behind the Museum of Natural History. It was on 83rd Street. The flat was on the ground floor, four rooms in a row with a bathroom nook and kitchen in the back. Steven took the front and I took the middle room and built a loft bed over the walk through. I had a window onto the light well, but it looked out at bricks. My view below was garbage and above, chickens lived in a coop on the fire escape. I remember thinking how odd it was living in the city and hearing a rooster crow at dawn. We had very little furniture, so the apartment looked like a narrow empty art gallery. In fact, I had my first one-person show there. **PLATE 14.**

ART IS LIKE AN ONION

Art is like an onion, sharp and sweet. Turn it around, look at it from every angle, peel away the layers to find what's at the core and you'll see nothing but your hands, smelling of onion. Art is found in the relationship between things. The initial re-

lationships are between the maker, the medium, and the driving emotion or idea. The act of the making or the designating is the experience of art. What is left of that experiential moment is the fact of art, the remains. A work of art is actually an arrested happening, an emanation of past time. This is a symbiotic relationship. A viewer may share the feeling, or experience a catharsis, with the artist's experience upon seeing what was left from that moment. In this way, the artist provides an experience for the receptive viewer via a medium between and separate from the artist and the viewer. I believe this to be a transformational moment, elevating the everyday. Art should be transformative. The antithesis of this idea is that art can be about nothing special or nothing at all. This dichotomy is one of many characterizing modern art throughout its secular history. This argument pits the aesthetic against the anti-aesthetic, and by extension, the subconscious against the self-conscious. For any one point of view about art, there will always be an opposite opinion. One spring day in 1973, I had an epiphany under a tree. For an extended moment, I felt I lost my sense of self in the vast universe. This elated and humble feeling felt transcendent. Freud described similar experiences as an "oceanic feeling of oneness with the universe." [3] I thought this transcendent moment should be expressed. This emotional, subconscious, and phenomenological experience determined the root of my ideas regarding art. Art could be a meditation on awareness and perception, an affirmation of Barnet Newman's idea that art is an immersion into the "Mystery of Life." Responding to the accusation that his paintings were not about nature, Jackson Pollock replied, "I am nature." Remembering Pollock's words, I thought of Emerson's Transcendentalism, a philosophy in which communion with nature resulted in the mystical surrendering of the self, an act epitomized by Emerson's own self-identification as a "transparent eyeball" before nature. [4]

 The human condition is one of living with dualities, of balancing opposites. These opposites can be described in many ways. For example, in Antiquity, the Greek gods Dionysus and Apollo epitomized the contrast between chaotic emotions and rational thought. Dionysus represented darkness, the Underworld, Earth while Apollo represented light, clarity, and the sky. Nietzsche used the terms "Dionysian" and "Apollonian" to separate the creative passion from the critical-rational. The artist creates by balancing opposites such as the unconscious and the conscious, the intuitive and the conceptual, aesthetic feeling and cognitive thought. Artists must find a premise for these issues and an order to the spectrum to begin an inquiry. Subsequently, their expressions are culturally interpreted. By the necessity of language, these interpretations are conceptually articulated. These cultural reflections may or may not be attuned to the artist's original intentions.

Some of these cultural viewpoints are:

 The aesthetic, which is expressive of a particular felt sensibility and the spiritual;

 The ethical, which is attuned to the moral;

 The theoretical, which articulates the cognitive mind, the didactic, and the literal;

 The historical, which references the contexts and definitions of art;

 The political, which addresses social-cultural issues;

 The commercial, which is foremost for the marketplace, decoration, status and entertainment;

 The anti-aesthetic, which is nihilism.

 An artwork can express one or a combination of these viewpoints, but not all equally. The artist must make a hierarchical decision ordering and addressing this spectrum of cultural positions. In addition, intuitively orognitively, the artist must make a decision regarding balancing the rational and the emotional. The artwork provides an opportunity for the viewer to decipher the artist's decisions. For example, early religious art can be understood primarily through the ethical and

aesthetic points of view, relying on faith as opposed to the cognitive. Many conceptual artworks of the 1960s and 1970s subordinated the ethical and aesthetic in order to emphasize the cognitive and the didactic. All artwork can be analyzed in this way, and part of the artist's work is to make decisions regarding the importance of these cultural points of view.

CONCEPTUAL LANDSCAPES

In 1974 I was painting landscapes. I admired artwork that expressed the emotional and the sensual. I studied Van Gogh, Bonnard, Monet, Vulliard, the more recent "West Coast School" of the 1950s and 1960s: Elmer Bischoff, Richard Diebenkorn, my professors, Norman Lundin, Michael Spafford, and Michael Daly, all "painterly" painters mostly in the romantic tradition. Essentially, this meant the artwork emphasized aesthetic intuition over conceptual strategies. Upon graduating from Columbia University, I moved from Seattle to spend a year in a cabin on the shores of Puget Sound. There, I began reading essays on conceptual art from the seminal books by Ursula Meyer and Lucy Lippard. [5]

I read that in 1969 artist Robert Barry released into the atmosphere above the Mojave Desert cylinders of xenon, helium, and other so-called noble or unreactive gases. He claimed he made energy an art form, saying "everything is a form of energy, objects are embodied energy, so why not use light waves as an art medium?" [6] This notion that art could be an idea transformed my notion of landscape painting.

In 1965, Joseph Kosuth presented his work, *One and Three Chairs:* a physical chair, a photo of a chair, and a print of the definition of a chair.[7] I wondered how this new "conceptual art" compared to aesthetic and ethical points of view. It seemed to me this art was purely in the realm of the theoretical and the historical. I thought of *One and Three Chairs* primarily as an example of theory, demonstrative and didactic. This art seemed opposed to the aesthetic, intuitive, and emotionally expressive art of the "West Coast School." Classical or pure conceptual art took place during the 1960s and 1970s. Pure conceptual art turned art into theory embracing linguistics, philosophy, and the dematerialization of the art object. This art can be considered classical or pure because it addressed theories of the framing and context of art, that is to say, art contextual definitions. At the time, art appeared to have defined boundaries against which acts, demonstrations, and words could press. Retinal art and a concern with aesthetics was a casualty of the reduction of art into pure ideas.

With these discoveries, I began to think about the dichotomy between two of the many viewpoints of art: the idea of art as an aesthetic expression versus the conceptual and the anti-aesthetic approach. In addition, I began to consider the early modernist notion of originality in contrast with art expressing concepts of appropriation.

BAD TASTE AND INDIFFERENCE

To understand conceptual art is to accept that theoretically, by the artist's designation, the thing or idea, thin air or the chair, can be art. Additionally, one must also accept the idea that an aesthetic consideration may not necessarily be a dimension of the artwork. Marcel Duchamp established this strategy and precedent back in 1913 with the first designated and appropriated object to become "art." He called a bicycle wheel fixed on top of a stool Bicycle Wheel, and it became the first "readymade." [8]

Duchamp once said: "You have to approach something with an indifference, as if you had no aesthetic emotion. The choice of readymades is always based on visual indifference and, at the same time, on the total absence of good and bad taste . . . in fact a complete anaesthesia." [9] In 1913, Duchamp's idea of indifference to aesthetics proved revolutionary. During that time he was associated with the dada-

ist movement. This group introduced the idea of anti-art and anti-aesthetics, which were expressions of "bad taste," in order to affront prevailing conventions of "good taste." This was a contrary commentary on perceived aesthetic standards. This approach differed from Duchamp's "readymades," which did not express the idea of "bad taste." Rather, Duchamp's intention was to express "no taste."

In the eighteenth century, good taste was the central idea on which the entire concept of aesthetics was based. Between 1916 and 1921, the dada movement rebelled against this idea of good taste. From this movement emerged the idea of anti-art, art not only in opposition to prevailing taste, but also the concept of art itself. The dadaists opposed the cultural establishments of the nineteenth century and bourgeois taste at the turn of the twentieth century. Art was seen as the function of challenging and breaking definitions of art and social boundaries of the time. The dadaists attempted to attract attention by transgressing perceived norms of taste. Throughout the course of the twentieth century, artists used this dadaist inspired effort to address social, political, sexual, and freedom of speech issues.

By designating *Bottle Rack* (1914) as a readymade artwork, Duchamp both appropriated industrial design and created an original approach to art making (or art designating) that would be forever associated with his name. His first readymade introduced the idea of proposing wholly non-art elements into the "artistic" aesthetic frame of reference. Ironically, his readymades were both a renouncement and an embracing of the idea of originality. The introduction of the idea of "not being original" was, in fact, initially an "original" idea. The power of Duchamp's concept lies in its irony. However, this irony is lost when repeated. In the case of the bottle rack, an appropriation of an industrial designer's creation could only be done once. After Duchamp, all artists who use this "strategy" of appropriation are truly demonstrating the ability to re-present unoriginal ideas. Essentially, Duchamp's idea was original, but the repetition of appropriation or of re-presenting came to express

a negation of the potential of an original or unique vision. Thus "appropriation" is an essentially nihilistic repudiation of what once was a central idea that defined art making: to create something original.

Appropriation may be, but is not necessarily, an act of anti-aesthetics or bad taste. The commonality of appropriation, anti-aesthetics, and bad taste can be defined as an intent to assault perceived cultural standards. After nearly one hundred years of art that addressed appropriation, anti-aesthetics, and issues of taste, and the subsequent cultural exhibition and institutionalization of these approaches, the pertinent question is: At what point does the precedent for these issues become established?

The modernist theoretical inquiry set out to define what art could be. Barry and Kosuth demonstrated this question clearly. This inquiry was conducted by using the logic of reduction, which is to say, the elimination of each aspect, one after another in order to see if what remained was still art. These aspects of art are inclusive of pure form, content, theory, and the aesthetic sensibility.

PRIME OBJECT

Fundamentally, this process of reduction was an effort to present a new prime object at each stage. A prime object is the source from which all derivations, reproductions, copies, transfers, and evolutions are produced. Creating original art introduces a new prime object. Michelangelo's *David* and Leonardo da Vinci's *Last Supper* are examples of prime objects. The paintings in the cave of Lascaux are possibly the first prime objects. As we get closer to the present, the ability to identify a prime object becomes increasingly difficult. Arguably, Picasso and Braque's cubist paintings, as well as Jackson Pollock's abstract expressionist paintings, could be considered prime objects. Over thousands of years, prime objects appeared at a slow pace, but on the advent of modernism, candidates appeared at a dizzying rate.

Recognizing prime objects requires categorization into classes or genres, such as the genre of painting, sculpture, or the enveloping category of art itself. Examples of other such classifications are architecture and technology. All of these classes remain open sequences. But every new form limits the succeeding innovations in the same series. Every such form is itself one of a finite number of possibilities open in any temporal situation. Hence, every innovation reduces the duration of its class. The boundaries of a class are fixed by the presence of a problem requiring linked solutions. The rule of series requires each position to be occupied for its corresponding period before the next position can be taken.[10] In other words, each proposition cannot occur before its time.

Since no two things can occur in the same spot or dot in space or on the same timeline, every act differs from what came before and what will come after. Therefore, two things or events cannot be identical, since every act is at an individual level an invention. To help us process the vast number of acts and inventions, we attempt to simplify our universe by arranging the infinite continuation of nonidentical events into a finite system of similarities. This is art history. It is the nature of the universe that no event repeats itself exactly, but it is the nature of thought that we understand events only by the identities we imagine among them.[11]

From the beginning of the Industrial Revolution and into the 1970s, modernism asked these questions: What is art, and how can art be reinvented? In their efforts to answer these questions, artists attempted to create new prime objects that were not based on precedents. Early achievements were broad in scope and addressed the totality of the problem while late solutions were limited and addressed the details. The narration of the story of modern art was about reduction, a narrowing of form, aesthetics, and content toward theory, which essentially led to the dissolution of the artwork itself. This ending manifested itself through appropriation, anti-aesthetics, pure concepts, and formlessness. All of this moved art toward the negation of the concept of originality by negating the idea of the prime object itself. Thus, form was replaced by theory. The three developments of anti-aesthetics, conceptual art, and dissolution are arguably the last chapters in the story of Western modern art. Following the logic of these developments leads one to realize that the end of modern art means giving up the idea of defining art.

Around 1944, Duchamp realized this conclusion of the idea of anti-art when he announced (albeit falsely) that he had retired from making art to play chess. Similarly, after 1917, the originator of the dada movement, Hugo Ball, began to renounce dada, eventually gave up art altogether, and became very devout, choosing to live in poverty among peasants until his death.

QUITTING DADA

The impetus to exhibit bad taste or art opposing norms, be it societal or artistic, might be traced back to the Salon des Refusés (Salon of the Rejected). In the 1860s, artists of the nascent realist and impressionist movements submitted works to the selection committee of the Salon de Paris, sponsored by the Académie des Beaux-Arts, only to be rejected. These artists mounted their own exhibit: the Salon des Refusés. The notoriety of these exhibits legitimized the idea of art that expressed opposition to prevailing standards. Rule breaking became the standard against which artists had to measure themselves.

The Swiss dada movement, which influenced all other dada movements, began at the beginning of 1918 in Zurich, at the Cabarat Voltaire. A number of figures came together in neutral Switzerland during World War I. Hugo Ball was the initiator who influenced all the dada artists, such as Tristan Tzara, Hans Richter, Kurt Schwitters, Hans Arp, Francis Picabia, Walter Serner, and Marcel Duchamp.[12] Another art movement, futurism, was born at the same time as dadaism. However, while futurism had an ideology and produced works to define it, the ideology of

dada was to not have an ideology. This concept of non-ideology allowed for dissention within the group; Ball ultimately promoted an ethical point of view while Tzara preferred anarchy. Ball wrote, "What we call dada is foolery . . . a public execution of false morality." Whereas Tzara proclaimed, "I smash drawers, those of the brain and those of social organizations: everywhere to demoralize . . ."[13] Dada introduced the idea of the destruction of all artistic forms, of rebellion, of negation, and of anti-art. Francis Picabia wrote in a 1919 manifesto, "Art must be unaesthetic in the extreme, useless and impossible to justify."[14]

At that moment in history, the concept of "anti" was new, and it was this concept that provided freedom from the prevailing aesthetic and social constraints at the beginning of the twentieth century. This freedom from precedents was something quite innovative in the history of art and set the course of modern art.[15] Eventually, the idea of "freedom from precedents" became a precedent in itself. Henceforth, everything had precedents. Thus, the idea of freedom from precedents disappeared. Opposition requires something to oppose; in the nineteenth century it was the Academy, and in the twentieth century it was bourgeois taste.

ART SHOULD BE UNAESTHETIC

The idea that art should be unaesthetic evolved from dada, and ever since, artists have grappled with this notion. For example, in the 1950s, Clement Greenberg's theoretical formalism avoided aesthetic considerations through pictorial problem solving. To make paintings was to define the essence of the genre of painting to be anti-pictorial and anti-illusionistic. Greenberg defined the essence of painting as anti-pictorial, anti-illusionistic, flat, and abstract. During the 1960s, instances of minimalism extended Greenberg's formalism through the reduction of the art object to its primary states and the processes of its making. For example, with his piece, Splashings from the late 1960s, Richard Serra established art as a process by throwing molten lead against a wall in his studio. Pure conceptualism of the 1960s and 1970s eliminated the consideration of the aesthetic object altogether by declaring art an idea, void of materiality.

Other permutations of the "unaesthetic" are intentions to be "nasty," to insult good taste, transgress social and cultural taboos. These acts, inspired by the spirit of dada, address sexual, political, religious, and social issues. The legitimacy of the transgression of social and cultural taboos comes into question when such transgressions have been institutionalized. In order for a gesture to be interpreted as an offensive transgression, there must be a boundary to transgress. Does an artwork cease to be "nasty" when it addresses a social or cultural taboo that is culturally recognized, accepted, and institutionalized? The rapid assimilation of historical taboos by modern culture means that the ability to outrage disappears. For example, since the advent of dadaism, artists have explored the idea of making "bad paintings" as an antithetical statement against perceived norms of "good" painting. In 1978, this notion was institutionalized by the New Museum in New York City with the exhibit *Bad Painting*. Does the idea of painting badly as an affront to "good painting" continue to resonate critically?

INSULTING THE PUBLIC

Dada was never institutionalized in its time. It never had a museum exhibition or academic examination (1916–1922). By this fact, dada remained true to Richter's proclamation, "pandemonium destruction, anarchy, anti-everything . . . In return for freely exposing ourselves to ridicule every day, we surely had a right to call the bourgeois a bulging haybag and the public a stall of oxen?"[16] This technique of disturbing and openly insulting the public, introduced by the Zurich movement, was later adopted in Berlin, Leipzig, Prague, Paris, and New York. Richter said, "It finally became clear . . . that the public likes nothing better than to be made fun of,

provoked, and insulted."[17] This is the birth of the idea that in order for avant-garde art to be significant it must outrage its public.

WHEN IS ANTI-ART PASSÉ?

Dada rejected the prevailing culture of its time, but by doing so, it introduced a precedent and a philosophical approach to art making that embodied the idea of "anti." Subsequently, this idea has been consumed and approved by the dominating culture. For almost one hundred years, this anti-aesthetic approach to art making has been the sine qua non for all artists who aspire to be radical. Yet, as a result of mainstream culture's embrace of "radical art," this once radical approach to art making has been integrated into the conservative art establishment. Ironically repetition, institutionalization, and identification within a style are attributes of what is considered conservative art. Since the 1970s, these attributes have also applied to the style of "anti-art."

CHANCE

Dada also introduced other lasting concepts to the art world. In his pamphlet *Final Dissolution* of 1918, Walter Serner stated, "This dissolution was the ultimate in everything that dada represented, philosophically and morally . . . The role of chance, not as an extension of the scope of art, but as a principle of dissolution and anarchy. In art, anti-art."[18]

In 1920, Hans Arp was working on a drawing, became frustrated, tore it up, and let it flutter to the floor. Upon realizing that the resulting random forms possessed all the expressive power he had tried in vain to achieve, he accepted this challenge from chance as a sign of fate. Richter said, "The conclusion that dada drew from all this was that chance must be recognized as a new stimulus to artistic creation. This may well be regarded as the central experience of dada, that which marks

it off from all preceding artistic movements."[19] The use of chance had opened up an important new dimension in art: the techniques of free association, fragmentary trains of thought, unexpected juxtapositions of words and sounds."[20] Arp became one of the most prominent exponents of the use of chance, eventually turning it into an almost religious presence. He said, "The law of chance, which embraces all other laws and is as unfathomable to us as the depths from which all life arises, can only be comprehended by complete surrender to the unconscious."[21] A prime example of Hans Richter's approach to chance is illustrated by his preference for "painting in the twilight . . ."[22] His approach was to paint in a dimming light in order to induce an auto-hypnotic trance that allowed for a picture to be sourced from the inner rather than the outer eye. Chance was his method to transcend the cognitive mind. Richter goes on to say, "For us, chance was the 'unconscious mind' that Freud had discovered in 1900."[23] Richter's early experiments with chance established the precedents for the painterly action and the absence of literal reference in the efforts of the abstract expressionists to draw upon the unconscious more than twenty years later.

TWO KINDS OF CHANCE

Richter attributes Arp as the originator of chance in art, but it may be Duchamp who truly holds this title, since he "created" between 1913 and 1914 what he called *Three Standard Stoppages*. He dropped three straight threads one meter in length from a height of one meter onto the same number of Prussian blue cloths. Then, he affixed them to the cloth without any adjustments to the curves into which they had fallen by chance. He later stuck the strings and cloth to glass plates. Wooden rulers were cut imitating the curved strings. Finally, all were encased in a wooden box. Moreover, during those years, Tristan Tzara composed poems out of randomly thrown newspaper clippings. Tzara was inspired by Arp's conscious use of his eye

and brain to determine the final shape, and thus retain, the ideas of authorship and transformation via the artist's vision. Refusing to allow the conscious self to have any part in the process, Tzara left the task of chance selection to nature. He negated the concepts of authorship and transformation. Here, the two paths of dada as well as "modern art" were set. Arp adhered to the idea of "balance" between conscious and unconscious, calling this a "balance between heaven and hell." This acknowledges the opposites stemming from Apollo and Dionysus. Tzara attributed importance exclusively to the unknown. This denial of aesthetic authorship essentially proposed the concept that everything is art once attributed conceptually.

Duchamp's assemblage, *Three Standard Stoppages*, is an early example of "conceptual art." As such, Duchamp and Tzara created art by using a kind of chance that was different from the one Arp employed. Arp's chance was "the voice of the unconscious soul" whereas Duchamp's and Tzara's chance belonged to the physical world of cause and effect: unmediated thrown pieces of newspaper or dropped strings. Psychological, subconscious chance is mediated; the body initiates an action of which the mind has not conceived. The result of the action invariably surprises the mind and therein is the expression of the soul. As Richter said, "This was the real dividing line." Dada thrived on the resulting tension between premeditation and spontaneity, or, as Richter preferred to put it, "between art and anti-art, volition and non-volition . . ." [24] Every artist and member of the art world must still decide on which side of this line they choose to stand.

PAINTING CANNOT BE ANTI-ART

Dadaist artists also invented assemblage and collage. By making their medium the clippings and detritus of everyday life, they attempted to reject the historical parameters that bound painting to the definition of art. At that time photography was a new medium. Coupled with found objects of little value, this assemblage and new photo collage approach was in opposition to, and in negation of, the historical tradition of painting. The dadaists employed these new approaches as an expression of anti-art. Although noting the countless museum visitors who appreciate the tradition of assemblage and collage today, we understand that when a movement becomes institutionalized, the philosophical message of "anti" is lost.

After the periods of abstract expressionism, formalism, and pop art in the 1950s and 1960s, some considered the genre of painting as dead. Inspired by dada and pop art, new forms of anti-art began to emerge. Richter once said about the dadaists (circa 1963): "In so far as painters were making works of art, paintings could not be anti-art. This is how visual artists preserved their independence while the dada movement pursued its erratic course, and this enabled art to survive unscathed the violent end of dada." This history shows that because of its tradition and acknowledged definition, "painting" is the hinge between art and anti-art. All other genres can easily slide into the ruse of everyday life. A sculpture may be a chair. A photo may be a sales sign, etc. However, as Richter pointed out, a painting cannot be anything but art, and therefore a painter cannot make anti-art. [25]

Richter explains further (circa 1963), "Picabia continued to make objects that resembled painting, thus his declaration that 'Art is dead' seems always to be followed by a faint echo: 'Long live Art.' With Duchamp the echo is silent. And that is not all: this silence renders meaningless any further inquiry after art. Art has been 'thought through to a conclusion'; in other words, eliminated. Nothing, nil, is all that is left. An illusion has been dispelled by the use of logic. In place of the illusion there is a vacuum with no moral or ethical attributes. This declaration of nothingness is free from cynicism and from regret. It is the factual revelation of a situation with which we have to come to terms!, a situation which Duchamp seems to have discovered rather than created. The counterpoint of Duchamp's non-art is amorality, emptying life as well as art of all its spiritual content. Here Duchamp took a logical,

and therefore necessary, step that was also a fatal one. He reversed the signposts of value so that they all point into the void." [26]

POP ART IS NEO-DADA

In the early 1960s, Richter also commented on the emerging art scene, "The anti-aesthetic gesture of the 'readymade' now reappears in neodada, as comic strips or crushed automobile bodies. These are neither non-art nor anti-art but objects to be enjoyed. The pleasure offered to the public is plain infantilism, however sauced by the descriptions of ingenious writers on art, who speak of neorealism, neofunctionalism, neodada [the style had yet to be called "pop art"] and heaven knows what else. What has appeared is a romanticism reinterpreted in terms of dada and surrealist experience, which enables one to look at things complacently. Uncompromising revolt has been replaced by unconditional adjustment. Duchamp's coal shovel, bottle rack, and pissoir can now be the objects of a calm aesthetic judgment, which was exactly the thing on which Duchamp vented his scorn forty years ago (1914). The prefix 'anti' has become a feather-bed on which the bourgeoisie and art collectors complacently recline." [27] He continues his critique: "Take motor cars half way through the crushing process: set up crumpled mudguards, newly painted. Dip a naked, well shaped girl in paint and roll her over the canvas. Put a stuffed dummy corpse in a pram. A musical performance in which the pianist sits at the piano for ten minutes and does not play. A theatrical piece in which not a scrap of theatre is performed. Feed a stuffed teddy bear with beaten eggs, hang a potato on an old lavatory chain. A pitch dark labyrinth in which the visitor to the gallery sprains his ankle. A hall with jukeboxes, rubber animals, and an artificial swimming pool . . . A shooting gallery where the customer aims at rotating bags of paint so that a direct hit splashes a huge snow-white sculpture with color. Mountains smoke, castles tremble, phalluses tingle, (and) the whole bazaar is sold out." [28]

Richter does not name the artists in this early 1960s rant, but I can surmise that some of the works he describes were those of John Chamberlain, Yves Klein, Piero Manzoni, and John Cage. Over forty years have passed since he penned these opinions, but the descriptions still retain their bite. They could apply to much of the "anti-art" exhibited today. He continues, "All these provocations (they are nothing of the kind [his words]) would easily outdo dada, if dada had not already exhausted the field. The repetition of a theme after forty years (between 1920 and the 1960s [my words]) does not improve it, but rather empties it of meaning, typifies an 'empty existence,' a vacuum." [29]

DUCHAMP WRITES A LETTER

Richter also states: "Looking at the thing from a superficial—but not entirely erroneous—point of view, these new pop-people have chosen Marcel Duchamp as their patron saint and placed him in an honored niche. But Marcel Duchamp escaped from this niche very quickly. In a letter dated November 10, 1962, he (Duchamp) writes to me (Richter): 'This neodada, which they call new realism, pop art, assemblage, etc., is an easy way out, and lives on what dada did. When I discovered readymades I thought to discourage aesthetics. In neodada they have taken my readymades and found aesthetic beauty in them. I threw the bottle rack and the urinal into their faces as a challenge and now they admire them for their aesthetic beauty." [30]

THE READYMADE WAS DEFINED IN 1964

After attending a symposium held on the occasion of *The Art of Assemblage* exhibition at the Museum of Modern Art in 1961, Richter quoted Professor Roger Shattuck, whom he felt defined the real problem of neodadaism, "Shattuck's point of departure was the same series of questions that Marcel Duchamp had answered

in dada fashion, forty years earlier, with his readymades, the coal shovel, the bicycle wheel, the urinal. The professor said that a Cézanne, or a Picasso, or any work of art could be seen again and again and yet afford new sensations, new emotions, new matter for meditation. The work of art is not exhausted by being looked at many times; on the contrary, it gains in the process.

This is not true of the coal shovel, the bicycle wheel, the urinal. They were not intended by Duchamp to stimulate meditation or artistic emotions; rather, they were intended to shock, to tear the beholder away from the stagnant meaninglessness of his habitual attitude to art, his conventional artistic experience. Such a shock is not repeatable. Upon seeing them for the second time, the coal shovel, the wheel, etc., are simple articles of use with no implications, whether they stand in their appointed place in one's house, or they make a pretentious appearance at an exhibition. They no longer have any anti-aesthetic or anti-artistic function whatsoever, but only a practical function. Their artistic or anti-artistic content is reduced to nothing after the first shock effect. At this point, they could be thrown away, put in some store, or returned to their normal role. As Professor Shattuck puts it, the (anti-) artistic value they used to possess has gone back to zero." However, Shattuck adds that "if, like Duchamp's, they are the first of their kind, such works may be preserved in museums." [31] Writing in 1963, Hans Richter noted that having participated in the beginning of dada in Zurich in 1916, he now saw the end, the irony, and the absurdity of continuing such a strategy. He said, "It is pointless to employ a shock effect that no longer shocks." Or, as Brian O'Doherty, the critic of *The New York Times,* wrote (October 31, 1963), "Things may have reversed themselves and now it may be the bourgeois who shocks the avant-garde." [32]

Richter also asserts, "This is not a rebellion, but the opposite . . . in fact, it might be called an artful attempt to enrich spiritual poverty . . . art may well become a packaged product, with the artist on the assembly line gulled into thinking he is an individual in possession of his freedom. Pop artists, the new realists, are people who hang old shoes on the wall and seek thereby to arouse emotions in us. But, as the shoes are only manufactured objects, these emotions fail to appear. Thus, while the artists experience a certain satisfaction in hanging up and exhibiting old shoes or chamber pots, the beholders are forced into a position of mental discomfort. They are therefore unable fully to appreciate the artist's irony and cynicism . . . this shock therapy brings us to absolute zero and writes 'finis' to the story of art as we knew it . . ."[33] Richter recognized this new art had co-opted the look of dada but not its intentions, its raison d'être. In fact, it was doing the opposite: the new pop art was an entertainment commodity, serving the bourgeoisie. Its irony made it hypocritical. Art was no longer about its makers breaking boundaries and being seekers of freedom or spirit. Instead, salesmanship and celebrity now defined it. Dada was honest in its insult to the bourgeoisie. On the other hand, pop art had a completely opposite purpose. For the most part, pop art embodied dishonesty in its aesthetic irony. In fact, it expressed an anti-aesthetic flippancy. The pose of "anti" was an attempt to confer the significance of status to the consumer, which was a ruse. This deceit continues on. It is notable to remember that Richter wrote this text before Andy Warhol was recognized as the master and innovator of this strategy.

CONFERRING STATUS

Meaningful status is conferred by respect. It is conferred by deeds done and things created. Buying objects to acquire status is illusionary, since showing wealth only shows wealth; it is not synonymous with status. Ostentatious wealth used to infer status is an exhibit of ignorance to those who have learned and earned the consideration of status for deeds done and things created. Anointing a commodity as art, for example, for a promotion to sell "art status" to consumers via Louis Vuitton bags actually does the opposite. By flaunting bags, the bourgeoisie and the artist

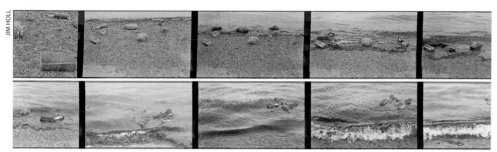

JIM HOLL

JIM HOLL

FIG. 01. *Tide, Moon, Sea*, 1974, rocks, rope, wood and sea, dimensions variable.

FIG. 02.
Hanging Rocks,
1974, rocks, rope, tree,
dimensions variable.

accomplice show their naiveté regarding the real meaning of the accomplishments of those who have earned status conferred by respect. The only respect that could be given in this example is to the person of Louis Vuitton, and even though he markets superficiality, he remains honest in his effort to sell a bag. Art is aesthetically compromised when designed to sell to a demographic. To appeal to many it must necessarily become banal. Selling to a demographic is in service of a function. By being a service it cannot be art. Art is uncompromised when expressing the singularity of the artist's being.

RICHTER COMES FULL CIRCLE

Referring to art as he knew it at the beginning of the twentieth century, Richter came full circle in the early 1960s when he wrote, "Fifty years ago, (writing in the early 1960s about the 1910s [my words]) the art gallery was regarded as a place 'in which the Gods spoke.' The works exhibited there, consecrated by tradition, by history, and by accepted criteria of value, constituted a reservoir of human experience and scales of values against which generation after generation could measure itself. (Galleries) are not there to be walked through, even if there are thousands of pictures in them, as there are in the Louvre or the Metropolitan Museum. They are there for meditation. I still think that one person who meditates before a work of art

is worth more than thousands who just gawp." [34]

WHY IS ALL THIS STILL RELEVANT?

In May 1922 Tristan Tzara delivered a funeral oration for dada. In 2008, more than eighty years after Tzara declared that dada was dead, it is remarkable that the issues dada brought to bear on the concept of art are still being recycled.

AESTHETIC INDIFFERENCE

In 1974 I experimented with Duchamp's idea of aesthetic indifference by letting nature make the artwork with as little interference from me as possible. I used lengths of rope to tie rocks to logs and let the oncoming tide create a kinetic sculpture. Nature made quite an expressive tangle. **FIG. 01.** By employing the tide and moon, I let time itself manipulate the form. This was the first of many efforts I made through the years to consider the concept of time as content. Upon reminiscing about this work, I remember the smell of the sea most. In another attempt to be "unaesthetic," I continued to use nature, to consider the concept of surrealistic disjunction by hanging rocks from tree limbs in an unnatural balance. My salient memory here was the wind. **FIG. 02.**

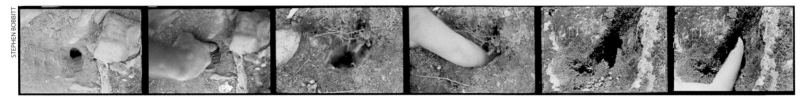

FIG. 03. *Man on Earth Communion*, 1974, artist and holes in the earth, dimensions variable.

As Richter demonstrated, anything a person reflects upon will allow for an aesthetic consideration. Duchamp's proposal of a bottle rack or shovel as an effort to deny an aesthetic consideration were actually pleasing examples of early industrial design created by an anonymous designer for functional purposes. The idiosyncratic form and patina that comes with age ultimately provides a strong aesthetic appeal. The example of Joseph Kosuth's *One and Three Chairs* comes closer to aesthetic banality, but nonetheless, the simple chair is pleasing to view. So, if you can see it, you can feel it. Robert Barry, of the invisible helium, shifted the issue of aesthetics purely to the realm of idea. Thus everything retains the potential to evoke a sensibility and to provoke a visceral, felt response if a person chooses to consider it–even an idea. Helium as art may be as dry a word-poem as can be, but I found it evocative at the time. Of course, there are degrees of aesthetic evocation: while a great hiaku poem lasts for ages, helium disperses quickly.

YVES KLEIN PERFORMS

I found that Barry's helium piece of 1969 was not the first time art had been reduced to almost nothing. In 1958 Yves Klein the French conceptual artist, presented an empty gallery as an exhibition of his art. The art historian Thomas McEvilley said, "He projected mental images onto the transparent space, creating immaterial paint-

ings . . ."[35] Then, in 1959, Klein established an elaborate procedure to sell "Immaterial Zones of Pictorial Sensibility," or areas of space in the sky. McEvilley believed that these and his other art acts served to "satirize the business of art and the sanctity of the art object."[36]

Klein's performances pointed out that it is the context that makes an object art. Indeed, context is itself the art. By negating the objects, Klein transferred the attention to himself. When the art became air, a transaction, or the audacity of the act, then the art became the artist. Klein defined the central issue when he said, "The artist only has to create one masterpiece, himself, constantly."[37] This transference of significance from artwork to artist was first achieved in America by a few of the abstract expressionists and pop artists, most notably Jackson Pollock and Andy Warhol. For Pollock this transference was accomplished primarily when Life magazine anointed him as the most important artist in America. But if Pollock's ego remained secondary to the inquiry of painting, Warhol used painting as a vehicle to gain and extol celebrity status. Consequently, the artwork was advanced as a signifier of status. By associating with the artwork, the consumer could "be like Andy."

Klein wasn't the only artist of this time who was concerned with the dissolution and contextualization of the art object. In 1961, the Italian artist Piero Manzoni exhibited a nude model and signed her as his work. He issued "Certificates

FIG. 04. *Broken Tendon*, 1974, artist, glass, dimensions variable.

22]

of Authenticity," which having been signed by the artist, declared that the model was a permanent work of art.[38] In 1959, Manzoni canned and exhibited his feces in an art gallery, offering these for sale for their weight in gold. The cans were nicely labeled, as a commercial commodity, much like a Campbell's soup can.

From these examples, I understood that art was an intangible construct that manifests itself first through the mind of the artist. The artist must examine and accept each premise employed in the creation of an artwork. I thought this is what it meant to be modern. Painting and sculpture were predefined genres. One had to cast off all preconceptions and start from nothing. This meant that art started first with the artist's self. This was the early premise of performance art: the artist as the artwork. For example, in 1966–1967, Bruce Nauman photographed himself as a fountain spewing water from his mouth. He called it *Self-portrait as a Fountain*.

In this spirit, in 1974, I enacted for the camera what I considered erotic communion with nature. While hiking in the forest, I thrust my limbs or myself into as many holes I could find. The piece concluded when fear of being bitten by what might be residing in those holes overtook my desire to create conceptual art. **FIG. 03.**

Could art be as an afterthought? I saw that Duchamp and Man Ray collaborated when they determined that dust that had collected on glass surface of Duchamp's *Bride Stripped Bare by her Bachelors, Even* (1915–1923) was indeed part of the artwork. While traveling, Duchamp had left the glass untouched in a horizontal position. On his return he found the glass covered with dust. After Man Ray's photograph of the glass, Duchamp chose to make this chance occurrence permanent by adhering some of this dust to the glass.

One sunny afternoon by the sea, I was repairing a broken window when suddenly my hand slipped and was impaled on a sharp shard of glass, severing a tendon that controlled my middle finger. I made the best of an unfortunate accident by deciding, in an afterthought, that this chance occurrence was indeed art. **FIG. 04.**

DEAD CRABS

The German conceptual artist Joseph Beuys used dead hares as sculpture. In 1965, he presented a performance titled *How to Explain Pictures to a Dead Hare*. The artist could be viewed through the glass of the gallery's window. His face was covered in honey and gold leaf and an iron slab was attached to his boot. In his arms he cradled a dead hare into whose ear he mumbled sounds. Almost ten years later, at the René Block Gallery in 1974, he staged a performance with a live wolf. He called it, *I Like America and America Likes Me*. The tendency to use animals as an art medium has continued today to the point of becoming a stylistic affectation. The first time I made animal art was in 1974. I gathered up a few crabs from beneath beach rocks

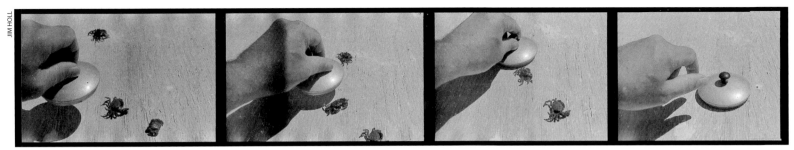

FIG. 05. *Dead Crabs*, 1974, artist, crabs, tea pot lid, dimensions variable.

and put them under the lid of a teapot so that the sun would fry them. While watching this process, I conducted an examination of my ethics. I realized an important ethical value is to consider art an act within nature. After *Dead Crabs*, art as an expression of an ethical idea became more than my reverence for the creatures of the world. It was also a recognition that life and art should acknowledge and bow to the human condition. **FIG. 05.** I thought art should be a process of creating a human expression reflecting all encompassing nature. This is humanism beyond the context of art. Becoming human is a positive process of becoming genuine, more oneself. I came to reject dead animals as art, and later, the nihilism of the insult and intentional bad taste that accompanies it.

THE PREACHER AND HARLEQUIN

In 1978, as a way of expressing the idea of being ethical, I posed as a preacher. The performances of *The Preacher's Principles* recommended assuming an ethical position from which to act. My intention was to create a performance to suggest that one reflect upon their social and economic interactions. Since ethics are a primary concern of religion, and one of the purported aims of religion is to break down human selfishness, I thought that the best symbol for this idea would be a religious icon. I thought these performances could be a particular statement opposed to the

selfishness rooted in capitalism.

Henry David Thoreau and Ralph Waldo Emerson's ideas about becoming a creative vehicle for the expression of transcendent nature influenced *The Preacher's Principles*. Also influential was the 1960 counterculture's emphasis on living off the grid, independent of the civilized world with the potential for original action guided solely by one's conscience. Inspired by those concepts, and by my youthful days spent hiking in the mountains, the performance expressed my own philosophy about the role of art and artist, which I called *Man on Earth*. This philosophy emphasized the consciousness of being a part of nature and drew attention to the intuitive underworld; the unconscious and the unknowable and the mystery of our self-conscious being.

As the preacher, I wore a costume made out of painted paper with big clunky papier-mâché shoes that symbolized feet firmly rooted in the earth. The performance was my attempt to affirm the idea of a "natural law" greater than society's law and the idea that art is more than a means to political, commercial, or social goals.

Up until 1975, my experience was, for the most part, limited to western Washington State, so it was not surprising that I was struck by the careerism, egotism, and capitalism of the New York art world of the mid–1970s. I was an idealistic young artist and thought that art would be a profession where these qualities would

LEFT: ROBERT PRICE. RIGHT: JIM HOLL

FIG. 06.
The Preacher's Principles, 1978,
artist, paper, plaster, wood,
dimensions variable.

FIG. 07.
The Harlequin, 1980,
paper, plaster, wood,
dimensions variable.

be recognized. When I realized, however, that idealism was of no cultural value, I enacted *The Preacher's Principles* as a reprimand to the art world. The performances occurred sporadically, at a number of sites and venues in New York City. One of these performances was the 1980 *Times Square Show*, which was held in a storefront on a pre-revitalized 42nd Street. I chose to say nothing during these staged performances. My desire to address a culture of competitive selfishness derived from my assumption that art should express something collectively meaningful. It was as if I were creating a visual image of a philosophical declaration through which the potential viewer could examine his/her conscience.

During these performances, I held onto my notion that art should be an aspiration toward a transcendent humanity, but I did begin to question the didacticism of the act, as well as the legitimacy of my doing the recommendations. I asked myself, "Who am I to be telling others how to act and should art be a lecture?" I then realized that as an expression of the Catholic creed there was another problem with the preacher.

The last of a series of these "acts" was during the annual Halloween Eve parade held in New York City. While parading alongside ghosts and witches, I handed out copies of *The Catholic Worker* newspaper to the crowd. One apparently devout Catholic came right up close to my face and said, "I'd like to smack you right in the nose." That incident made me examine the irony of my costume. I intended my message to be idealistic, meaningful and authentic but, I was actually being ironical. The near punch in the nose lead me to the realization that it was rather fraudulent to pose as a preacher. I was unethical while trying to be ethical. That was the end of that project. **FIG. 06 AND PLATES 01 THROUGH 08.**

Hidden Noise was the title of an art object constructed by Duchamp in 1916. It consisted of two metal plates screwed together from opposite sides of a ball of string. Inside lay something hidden that rattled when the ball was shaken. In 1983 we started an artist group by that name and staged a series of installations in display windows on Broadway near Spring Street in New York City. One of the installations showed the last time the preacher preached, and the only time the preacher spoke, *Self-Interest Never Never Saved the World*. This exhibit was a critique aimed at the "trickle down" theory of economics advanced by the Reagan administration. **PLATE 09.**

Traditionally, the harlequin stands outside society in order to reflect on the human condition. So, I decided a harlequin was a more appropriate alias than a preacher. In the 1979 performance piece, *The Harlequin,* I posed as "Old Man Time" transforming a young girl into an old lady. This was one of many attempts to express the experience of time. **PLATE 10.**

THOSE WHO POSE

Conceptual artist Joseph Beuys posed as a shaman always seen dressed in a flack jacket, army boots, and a fedora. Pop artist Andy Warhol appeared as a dandy modeled after Oscar Wilde. The end of the 1970s was a time of role-playing that was antithetical to the idea of authenticity. Contemporary media culture continues to thrive on the idea of counterfeit selves. The public's infatuation with identifying with fabricated personas can be seen as the attempt to graft the qualities of the actors onto their own lives. These qualities may include glamour, status, beauty, rebelliousness, etc. The inability of the populace to find within itself the meanings or satisfactions that these qualities attempt to represent is exploited by popular media culture. This culture promotes a diversion from the practice of self-reflective experience. By promoting the illusion of satisfaction through celebrity identification and consumption, holes in the fabric of people's lives are artificially filled by fraudulent personas and products. They are fraudulent on two counts: seldom is a celebrity genuine, rather, in order to become a lure, idealizations and sensations invariably substitute for the banality of honesty. Secondly, rarely does a product "satisfy." Even though promoted to do so, invariably, it is a lure that is deftly substituted for another product so the public's yearning continues. In order to continue the consumption of products they must ultimately fail to satisfy. In order to inspire the public to want the products there must be a lure, something unattainable. Keeping the public yearning is the reason for the product. This is the marketing strategy for fashion. In the case of public personalities advancing their popularity, ambiguity and aloofness enhances the "lure." The "lure" is to know the personality, which will never be revealed.

Andy Warhol's greatest contribution to art was his understanding of this strategy. In my opinion, his most significant works are the Elvis and Marilyn paintings, for here, he grafted popular icons onto himself. In a kind of necrophilia, he assumed the personas of the pop icons via the paintings. It is important to understand that it was not the formal qualities of the paintings themselves that were significant; rather the lure was the iconic content. Warhol's intention was to be offhanded and indifferent regarding technique. This approach allowed iconic status of Marilyn or Elvis to be the emphasis. When the public consumed Marilyn, Andy benefited twice. Not only did he get to be like Marilyn, he also basked in the public's yearning to be like Andy. Joseph Beuys was Warhol's European counterpart. If Warhol embodied the superficiality of popular culture, Beuys did the opposite. He embodied qualities of the intellectual, priest, and shaman.

I was there when Beuys made an appearance at P.S.1 around 1977. This was when Project Studios One in Brooklyn was still an independent art venue, before it became annexed to MoMA. Since the school hadn't been renovated yet, it still retained its worn charm. The event was held in the top floor gym, the largest open room in the building. The room was full of artists awaiting the arrival of the renowned Beuys. The crowd was milling about when the celebrity artist in flack jacket strode in with his escort. I remember him walking the length of the floor and standing in the middle of a huddle for a few minutes and walking back out. That's all I remember of that event. What made the moment stick in my mind were all the other artists in the room in odd outfits; walking sticks, cowboy hats. At the time, a unique persona seemed to be a required attribute for the serious "avant-garde" artist. It struck me as funny to see everyone in costumes, adjusting their hats, posing as soon-to-be famous artists. A character like this would stand out on the street, but here, it occurred to me, we were a crowd of clowns. This is one contribution that Beuys and Warhol gave to the art world: an act. This was a long way from the abstract expressionist idea of art as the expression of what it is to be genuine, to express the primordial, subconscious, and transcendent self.

The end of the 1970s was a time when the art object disappeared, the canvas became bare, the sculpture became air, the thoughts became the object, and the

artist became an actor. I continued to entertain the thought that art was fundamentally about a self-discovery that began each morning when looking in the mirror. In 1977, this was not the prevailing train of thought; instead, one needed sunglasses, a wig, and leather.

THE ARTIST IS THE ART

Bruce Nauman as a fountain spitting water, arms outstretched into the air, was art. Yves Klein said every breath you breathe is art. Art became immersed in the artist's ego. When this happens, the scarcity of the mediation, the middle part, the "art thing" that mediates between the viewer and artist poses a problem. When art became a prop, the artist became a performer. Religious services are performances that, in the best cases provide a catharsis for the faithful. Theater is a performance that elicits empathy from the audience through the telling of a story. Performance as art may both elicit empathy and provide a catharsis, but only if the performance transcends, as do the religious ritual and theatrical play, the individual actors. Transcendence is enabled by an effective story.

When a performance is a ritual–a rite for the performers themselves–a redeeming value in the experience is possible for the performers but not necessarily for the viewers. When art becomes the body persona such as "I am art," as in Klein's declaration, "I am the Void," [39] the artist essentially anoints himself as the art. When Klein projected mental images on blank walls and called that art, he was anointing himself as art. When this self-claim for the mantle of art occurs, it does not allow for a catharsis by the viewer, but rather it separates, condescends, and alienates the viewer. Art becomes didactic, a spectacle or a provocation. It eliminates the potential for shared meanings as well as the idea of the artist as a vehicle through which expression becomes manifest apart from the artist. If self-referential or art-contextual art renounces the idea of expression transcending the artist, manifested apart from the artist, then it also seeks to negate the possibility of an aesthetic point of view. As an aesthetic point of view inspires a felt response, it is necessary for art and performance art to provide the viewer with the experience of empathy, a symbiotic relationship. A conceptual, cognitive understanding is not conducive to this kind of emotion. Performance art that does not achieve or attempt to connect emphatically to the audience shifts the subject of the performance onto the artist. When the persona of the artist becomes the art the subject of the art becomes the artist's ego. On witnessing many performance artworks during the 1970s and 1980s I came to suspect an undue sense of self-importance on the part of the artists. When the artist's ego becomes the art all other narratives are sublimated. As I came to understand this I addressed the problem in my own performance efforts by presentations to transfers the subject from myself to the props. By exhibiting the costumes of *The Harlequin* and *The Preacher*, the props became performance art "once removed." The costumes as "sculpture" referenced the "actor" as well as the past performance. **FIG. 7, PLATES 07 AND 08.**

THE VIEWER FINISHES THE ARTWORK

By shifting the subject to the viewer the problem of the ego as subject was countered. To achieve this, I had to make the viewer integral to the completion of the artwork. When the viewer participated, the subject shifted to their participation in completing the artwork. An early example of this approach was the 1977 installation *Peg and Slot Games*. These were a series of wall reliefs that implored the viewer to solve a puzzle, such as putting a peg in a slot. The artworks were linear constructions intended solely to make the viewer think of how to solve a puzzle. This engagement implied that the viewer was the subject. None of the puzzles worked. Either the slots didn't fit the pegs or the visual clues were illogical. In this project, the form of the artwork was not intended to evoke feelings; rather, it served simple, clear functions. Every element of the work was placed unsecured, enabling the possibility of movement. By emphasizing conceptual functionality and rudimentary

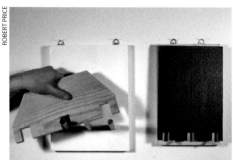

FIG. 08.
*Peg and Slot Games,
the Sculpture and the Painting,* 1977,
artist, wood, paint,
17" x 12".

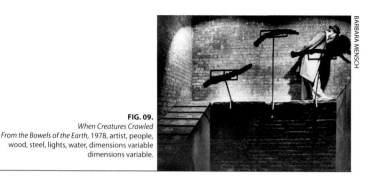

FIG. 09.
*When Creatures Crawled
From the Bowels of the Earth,* 1978, artist, people,
wood, steel, lights, water, dimensions variable
dimensions variable.

craftsmanship, a critique from an aesthetic point of view was not applicable. I concluded that suggesting viewers participate solved egocentric problems associated with persona-driven art. **FIG. 08, PLATES 11 THROUGH 15.**

Considering aesthetics Barnett Newman once said, "The impulse of modern art was this desire to destroy beauty." [40] This was one of many edicts that warned of the problem of regarding aesthetic beauty as a goal in itself. With the *Peg and Slot Games* I felt I had addressed, through functionality, the idea of indifference to aesthetics. In addition the diminutive scale of the work expressed personalization. In 1977, I thought this was a way to address the impersonal industrialization of minimal art and the immateriality of classical or pure conceptual art, which dominated the art issues of the day.

WHEN CREATURES CRAWLED FROM THE BOWELS OF THE EARTH

The subject of an artwork can be the artist, object or viewer. *When Creatures Crawled From the Bowels of the Earth* was an installation and a performance piece where the subject was both the artist and the viewers. This project was installed in the subbasement of P.S.1 in 1978. The installation was inspired by Dante's *Inferno,* where he embarked upon a journey through Hell, exploring the darkest impulses of humanity. In a lighter vein, the installation was inspired by the idea of a "Halloween

spook house." The viewers, upon participating in this journey, literally become its subject. The artist echoed the viewer enacting the journey for the camera. Diminutive signs, like small characters, provided the viewer with directions down a narrow winding pathway. The first sign said: "Enter at your own risk," while the rest were animated without words, pointing the way behind the boiler (the caldron of Hell) over a foot-plank bridge across a pool of black water (the River Styx of the underworld, on which gods swore their binding oaths). Signs pointed the way to turn again and again until arriving at a stone "cave" (formerly the coal room). A ramp led to a raised stage lit with spotlights. The viewers found themselves on stage, in the "limelight," the subject of a personal performance of self examination. Across the stage leapt a sculptural sequence of serpents made and suspended from the simplest of materials, the "magic" of the trick revealed. On the other side of the stage was a platform with a hole, and then a ramp for the viewer to descend. As the viewers crossed the platform, the ceiling lowered, forcing them to bend and look down between their legs to see the hole from where the serpents leapt. This pit in the floor was illuminated by black lights revealing the very "bowels of the earth."

This narrative, much like a play, guided the participant through a construction concerned with the exploration of the underworld, the subconscious, and the animal life-spirit that exists below the cognitive, the Dionysus impulse. I re-

FIG. 10, 11.
Civic Plots, 1983, people,
sand, steel, wood, shoes,
money, dimensions variable.

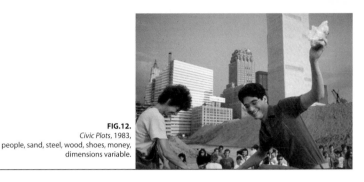

FIG.12.
Civic Plots, 1983,
people, sand, steel, wood, shoes, money,
dimensions variable.

member Marcia Tucker, who was at the time was the Director of the New Museum, telling me she went to her knees to cross the foot-plank bridge over the water. Her response showed me the work evoked, as I had hoped, a visceral response from the participants. **FIG. 09, PLATES 16 THROUGH 23.**

ART ON THE BEACH

The last poseur performance and audience participation event I engaged in was in 1983. Creative Time sponsored *Art on the Beach* a collaborative summer art exhibition. The beach, bordering the Hudson River, was a landfill made by the excavation for the World Trade Towers. It was conceptually and literally a multilayered event conceived by collaboration between architect Elizabeth Diller, performance artist Kaylynn Sullivan, and myself. The driving concept was to make the audience the subject. For this to happen the audience had to become the performance, and the artwork had to become props. We took note of the close proximity to Wall Street and chose to critique capitalism by giving the grant money away. This was the lure to insure that the audience would join in, becoming living art on the performing "stage," or in this case, "sand landfill."

On another level, this art project used our cultural and economic system as subject matter. This was achieved by turning corporate capital investment into an art commodity. At the time, I had clients in the commercial world who were looking to save on investments in products that were not selling: shoes. One South Korean client made inexpensive dress shoes, the other from China made slippers. I arranged for a third party, The Public Art Fund, to accept a whole lot of shoes as donations, which became write-offs for the corporations. The Public Art Fund then allowed me to designate as art, this one-time commodity (admittedly, an act of appropriation). Theoretically, this reversed the normal process whereby artwork is turned into commodity.

The form of the installation centered on a structure Diller called the "Sentinel," a booth with an interior space and portal. It had an animated appearance with outstretched arms that moved with the sands of time streaming though a metal cone. In front of this booth were two symmetrical hills of sand delineated in square boundaries. One of the hills was literally a boot hill. Old shoes painted black covered the top. This was a visual segue. In front of these hills were numerous abstract megaphone sculptures standing together like people casually facing one another. At the center of each megaphone was a tape recorder.

The audience assembled facing this environment. On cue Kaylynn and the troupe appeared "ritualistically" (reminiscent of performances of the time) before the crowd. While passing out invitations to visit the "Sentinel," she enticed an

audience member (a stooge) to dig into the "boot hill." The Chinese slippers were painted gold (appropriately gold slippers) and inside the slippers the grant money was divided into denominations between five and fifty. The slippers were then buried in the hills of sand. "Viola!" shouted the stooge upon finding a gold slipper. As the crowd then crossed the presidium to dig into the hill, the megaphone tape recorders were turned on and began, as did the audience, to chatter with one another.

The critic Kay Larson said of the event: ". . . but at the last moment, life began to mimic art to a degree that no one seemed to expect. When people began to uncover real money, some went a little crazy. Hours later, long after all the tokens had been found, when the landfill was overcome with dusk, they were still frantically excavating. The image sears the mind. It recalls with eerie precision Faulkner's *The Hamlet*, which ends as a poor crazed farmer has been fooled into selling his farm for buried gold. He digs for days but is only digging his own grave." [41] Art writer Grace Glueck commented, "The performance part of this work, ringmastered by Miss Sullivan, included an audience search for 100 golden slippers, buried in each mound, that can be redeemed for 'treasures' at the booth. The idea according to Mr. Holl is to make each viewer 'responsible for experiencing a work of art' by encouraging direct participation." [42]

I posed as a harlequin in the "Sentinel" booth with boxes of dress shoes. The audience formed a line to redeem their tokens for new shoes. The art performance was over when the capital was given away; all the shoes were handed out and the leveled sand hills produced no more money. I thought this an absurdist and irrational event in the tradition of dada. The project, titled *Civic Plots,* addressed art contextual issues by crossing conventions of commerce, combining site-specific sculptural elements, chaotic narration, metaphors, sound, and people who both experienced and became art in real time. Reflecting on the experience, I thought it to be tangential to art theory. It seemed to transgress the idea of art altogether. Hand-

ing out shoes in a costume from a booth and then having returns for a size that fit led me to think back to my youth as a shoe salesman dressed in a JC Penny outfit running back to the storage room to find for the customer a size that fit. It was as if the audience were at the mall and was happy when something was free. When the crowd finally dissipated, a woman came up to me, the harlequin, with tears in her eyes, gave me a big hug, and said that I should meet Yoko Ono. This should have touched me, but instead, I thought of the disconnectedness of my original intentions and the reality of the lives, expectations, and instabilities of other people. I saw that I was trying to impose my content onto the viewer. The viewer, however, brought his/her own content to bear upon the event, each experiencing something entirely different. In addition, many people stole the tape recorders.

This was the last time I was a performance artist. For the most part, I thought I had exhausted the idea of shifting the performer artist-as-subject of the art onto the viewer-as-subject of the art. I thought the logical conclusion of that concept to be group therapy, which, ironically, I experienced years later. *Civic Plots* was not the first of its kind. Earlier examples of interactive performances can be sourced back to Yves Klein's empty art gallery openings in the 1950s, Allan Kaprow's 1960s happenings, and others.

As if all these precedents had not taken place, recently critical acclaim has been bestowed on artists who enact situational interventions. These examples of conceptual art are in the vein of what the French critic and theorist, Nicolas Bourriaud, has called "relational aesthetics." The idea in relational aesthetics is to abandon making objects in favor of creating situations in which all visitors participate in creative social processes. [43] After the interactive experience of *Civic Plots* and my subsequent experience as an art teacher, I formed the opinion that this kind of activity as art is most effectively done when engaged if not in psychotherapy, then in art schools, simply for the availability of guidance.

The experience of *Civic Plots* was for me the beginning of a process of recognizing the possibility of allowing viewers to determine content for themselves. It also freed me from the need to personally engage the audience. Following this project, I made political and literal artwork that addressed various "causes." But I began here to consider that art making should be intrinsically gratifying to the artist and should not be a didactic demonstration, trumpet a cause for its justification, or be an art historical problem solving activity.

FIG. 10,11,12, PLATES 24 THROUGH 29.

END OF ART

Arriving in New York in the mid 1970s provided me with the opportunity to witness the waning of minimalism and pure conceptualism. I remember seeing Carl Andre's grid steel plate floor sculptures at the Paula Cooper Gallery, scatter pieces by Barry Le Va, and monochrome paintings by Ellsworth Kelly and Brice Marden. Sculpture had come off the pedestal, lost the artists' touch, and had become expressive of the process of its making. Painting lost the figure, became a flat monochrome ground, an object, like relief sculpture. Objects were no longer singular, but relational to one another and space as site-specific installations.

The history of modernism, a history of erasures, began to take place in the mid-1880s. Van Gogh, Gauguin, and others repudiated the entirety of their own artistic pasts and sought their influences in Japan, Egypt or Polynesia. Manet and Cézanne flattened pictorial space and pictorially proposed the process and medium as inclusive to the subject of painting. Arthur Danto sums it up succinctly, "Modernism in art was a narrative of problem solving, a certain narrative of breaking through art contextual boundaries. The history of modernism beginning in the late 1880s is a history of the dismantling of a concept of art which had been evolving for over half a millennium. Art did not have to be beautiful; it need make no effort to furnish the eye with an array of sensations equivalent to what the real world would furnish it with; need not have a pictorial subject; need not deploy its forms in pictorial space; need not be the magical product of the artist's touch. All these subtractions were achieved over the course of decades, making it possible for something to be art which resembled as little as one pleased the great art of the past . . ."[44] "It seems to be a law of modernism," Clement Greenberg wrote, "that the conventions not essential to the viability of a medium be discarded as soon as they are recognized."[45]

The last chapters of modernism concluded in the mid-1970s with the institutionalization of minimalism and conceptualism. I didn't know it at the time, but this was an end of the modernist narrative. By 1980, modernism had given way to post-modernism. The reductive trend of modernism had run its course. When the art object had been reduced to its primary nature and process, such as Carl Andre's square steel plates prone on the floor or Richard Serra's molten steel thrown against the wall, the question of the object and process as art could not be reduced further. Pure conceptual art succeeded in eliminating the object altogether reducing the art to the consideration of an idea. This disappearance of art, when considered through the narrative lens of modernism, seemed complete in the mid-1970s, but in fact, Duchamp presaged this development with his readymades, conceived in the 1910s and 1920s. The concept that art and life are interchangeable, that anything can be art via the artist's designation, eliminated everything at once and transformed it into the discourse of art as philosophical theory.

Although Danto acknowledges the "what is art" question was being raised all across the art world in the 1960s, he chooses Andy Warhol's Brillo Box as the quintessential example. Danto wrote, ". . . with the Brillo Box, the true character of the philosophical question of the nature of art had been attained. Closely connected with this . . . appropriating a famous thesis of Hegel's, that with the disclosure or discovery of its pure philosophical nature, art attains the end of its history."[46] In order

for a Brillo Box, or an earlier example from Duchamp, the shovel, to be considered art, one had to have a grounding in modern art history construed as a history of erasures, and also a notion of an enfranchising theory that these "readymade" objects addressed. Danto states that in order for the Brillo Box to be seen as art, "one had to participate in a conceptual atmosphere, a discourse of reasons, which one shared with the artists and with others who made up the art world."[47]

In addition, Danto asserted, "In order to see in what way it was art, a theory was needed as to the nature of art, and that art, historically considered, was raising from within itself the question of its being . . . the answer to the question could not come from art, which exhausted its philosophical powers in raising it, and that the task for philosophy now was clear. Until the form of the question came from within art, philosophy was powerless to raise it, once it was raised, art was powerless to resolve it. That point had been reached when art and reality were indiscernible."[48] "Two things now have to be said about these status-conferring reasons: first, that to be a member of the art world is to participate in what we might term the discourse of reasons; and secondly, art is historical because the reasons relate to one another historically. Brillo Box had a shot at being a work of art because of the fact that so many features, thought to be central to something's identity as art, in the years leading up to that, had been rejected as part of the essence of art, so that the definition itself had become attenuated to the point where pretty much anything could be a work of art. A member of the art world would be one who was familiar with this history of attenuation."[49]

The end of this modernist narrative means that regardless if it were attained in 1916, 1964, or in the 1970s, the reductivist paradigm was over. The question of defining art by erasures was moot. Thus, there is greater artistic freedom because there is no longer a dominating issue to address. Imagine the futility of being a figurative painter in the heyday of abstract expressionism. I came to realize in the early 1980s that the hegemony of a dominating style no longer reigned, that every artistic approach was now permitted because a historical mandate no longer existed. Danto asserts, "Art can be externally dictated to, in terms either of fashion or of politics, but internal dictation by the pulse of its own history is now a thing of the past."[50] According to this logic, all art will henceforth have a point of reference, which means anything presented as art will be in the purview of a "style."

STYLE IS THE CHILD OF THE PRECEDENT

The definition of style is the practice of art within the reference(s) of historically established artistic premise(s) and with an acknowledgement of precedents. Contemporary paintings in the historically premised style of abstract expressionism are an example. An art "breakthrough" is the introduction of a new premise for art making that surpasses the existing one, such as what pop art was to abstract expressionism. The first pop art or cubist pieces were not based on a style. They were the examples of artists who found a new way to make art, created a new paradigm. By others' recognition of the artist's invention the term "style" is coined. Cubism as practiced now is created within the parameters of its accepted style. This is true of art created in the tradition of dada, conceptualism, minimalism, etc. Once precedents are established, further practice references the originating precedent. This edict is inclusive of the post-modernist inquiry, which for the most part is the combining, or collaging, of various historical styles. Often this post-modernist strategy is an end in itself; the collage of clashing references cancels further meanings. The advent of post-modernism signaled the end of breakthroughs. In addition, the institutionalization of anti-art and anti-aesthetics rendered it impossible to propose anything artistically unprecedented. By including anti-art as art, anti-art became not only a style, but also a contradiction unto itself. Everything one intends to be considered within the context of art now had a precedent. The object or act would inevitably

reference some historical precedent. Any artwork that is described as "new" will still derive from existing precedents.

This is not to say that discoveries and inventions do not continue to occur. Certainly, "breakthroughs" occur in fields not traditionally considered to be art: science, media, technology, interactive communications, etc. If we consider the anti-art dictum that "life is art," then hypothetically, inventions in other disciplines can also be considered "breakthroughs" in art. This casts the idea of radical art in a different light. Stem cell research is radical. How does that compare to a "readymade" artwork of any sort? If the "readymade" led to the end of the art historical narration as it had been told, then the goal of making "life" art has been reached. The dadaist anti-artist proposed everything could be considered art if the artist designates it as being so. Therefore, can the new inventions, cutting-edge technologies, nano-robots, biological computers, microsurgery, drone warfare, global communication networks, global positioning systems, virtual simulation, exotic drugs, stem cell research, etc. represent a new avant-garde if it is considered art? Is this the new radical art, the "breakthrough" art? The caveat is that these remarkable inventions are in service of causes, they are tools, not theoretically, philosophically, or even aesthetically attenuated to the pre-"anti-art or life is art" theory of art. Therefore, to merge art with all other disciplines that retain their defining boundaries, such as science, means contemporary art would be dissolved as a distinct activity and institution in society. Art must dissolve its defining genre in order to merge with the truly radical inventions that are taking place in the aforementioned fields. For example, what if the document, or monument, the painting or sculpture, the singular point in time and space were to give way (as is happening) to the dispersed and reproduced, distributed across media culture? Will this fracturing cause both the traditional art forms inclusive of anti-art to fade into history? Rather than art ending as a genre of human inquiry, I expect the splintering will multiply genres allowing ancient disciplines like painting and sculpture to coexist with all contemporary media and cultural innovations.

The breakthroughs in science and technology are tools serving functional goals. If these inventions are re-presented in art institutions, they reference the cause from which they originated and serve. The originating reason establishes their precedent. Therefore, they immediately fall within the definition of style when they are transferred from their original discipline and re-presented as "art." The intention of this theory is to underscore the notion that everything in the future that is exhibited within the context or institutions of art will be created within the purview of historical style(s). Thus, the contemporary artist's choice is to determine one's content and to determine how it will be cast in a particular style.

In this time of laissez-faire aesthetics, if every style is acceptable the only approach that is no longer possible is to try to make art with no style. These are latter-day dadaists, conceptualists, and anti-artists who fail to understand that when anti-art became a style it was the end of the historical narrative of the negation of styles. Anti-art is ironic; it makes art within the "style" of not making art. Anti-artist is a contradiction. The epitome of anti-art is life. When life was designated to be art and when that designation became within the purview of a style (through repetition and precedent) it ceased to be radical. Anti-art is impossible because it always becomes art. Those who continue in this vain attempt to be "radical" are simply naïve. The last "radical" gesture the contemporary "anti-artist" is left with is the insult and the transgression of social taboos.

At the current moment, an issue more relevant than anti-art is the idea of "laissez-faire" aesthetics. When everything is permitted and acceptable in the name of art when any style is in itself no better or worse than another, what are the criteria for judgment? In order to answer this question, I suggest one approach from an ethical point of view. For ethics can be one measure for judgment. To judge an art-

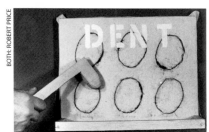

FIG.13. *The Entourage, The Painting Demonstration, Do Did Dent,* 1977, installation detail, canvas, wood, oil paint.

FIG. 14.
The Entourage, The Mate's Breasts Dented her Blouse, 1977, installation detail, wood, rubber.

FIG. 15.
The Entourage, Bismark, Arizona, The Place to Put, 1977, installation detail, canvas, wood, oil paint, rubber.

FIG. 16. *The Entourage, Briefcase Flaps,* 1977 installation detail, detail, wood, handles.

work, when every style is acceptable, is not to question the style chosen, but rather it begins with the question: What is the art expressing? In determining whether art is good or bad, one must start by considering if it is a positive or negative contribution to life. If it is a negative expression intended to right a wrong, then the negative is justified. With that exception, a positive expression, a humanistic expression, is the measure to begin to judge.

Style is the means, the vehicle, to deliver the understanding of the literal and latent content. Style in a successful work of art will be sublimated in order to emphasize the literal and latent content. Style should not call attention to itself; if it serves the content, it will not overstate or understate. When style becomes the emphasis, for example rococo, the art, in my opinion, becomes superficial. In addition, I suggest one should not be impressed or put-off by techniques or mediums, high or low. When technique calls attention to itself, the artwork becomes decorative and pretentious. Attending a recent art fair I overheard a gallerist explaining to a couple how the artist made the artwork. The technique wasn't apparent. In order to hear if the gallerist would add something else about the artwork, I asked the same question. She happily repeated herself. The question was about the technique, but the explanation didn't offer any additional information regarding the "art" of the artwork at all; it was merely how the artist achieved his effect. This

was a reminder of the difficulties in conveying the essential meanings some artists hope to express.

However, back in 1978, none of this had occurred to me. I did know that according to the history of modernism, in order to establish a new paradigm, the art of the moment had to be surpassed by another model. Therefore, I couldn't follow in the footsteps of the trends of the moment—the minimalists or pure conceptualist. I needed to move away from the minimalist idea of process and material and art contextual references and instead bring a different subject to the work, a narrative outside direct referencing of the art contextual discourses of the time. Through performance art, I had experimented with using myself as the subject, and through interactive installation, I had experimented with using the audience as the subject. I decided that the only way to remove the ego, the subject of the person, artist or audience from the artwork, was to assume the structure of a theater or a "play." So I invented a cast of characters and told a story.

THE ENTOURAGE

The Entourage was an installation exhibited at P.S.1 in 1978. It was a narrative conveyed through sculpture, paintings, photographs, and text. This was the beginning of an approach to art-making that combined mediums and genres. I thought this

approach was a way to avoid issues regarding definitions of painting or sculpture, as well as the dominating genres of the day: conceptualism and minimalism. Without being aware of it, I had begun to engage in the additive collage approach associated with post-modernism.

My effort was to mirror the text through the object/image. Each object/image visually re-presented the language so that the content determined the form. The exhibit included musings, such as references to a primary definition of painting *(Do, Did, Dent)* and oblique puns regarding notions of romantic ideals as ends in themselves *(Bismark, Arizona, The Place to Put)*. At different moments, the installation suggested viewer participation by providing handles on the briefcase ("flaps") and a mallet to dent a painting. I presented the narrative as text on the wall accompanying the photographs and sculpture. The quasi-mythic narrative portrayed fundamental human conflicts.

One influence for *The Entourage* was Duchamp's *The Bride Stripped Bare by Her Bachelors, Even (The Large Glass).* The parallel was that both were encoded via a personal iconography. My installation told the story of a meditation between one character represented by the Mate who gave a lecture "Put, Put, Put, Do, Did, Dent." She possessed the confidence to act. "The Deciding Man," another character, was caught in self-doubt, vanity, and fear. However, unlike Duchamp's work, *The Entourage* was executed using simple and primitive means. The simplicity allowed for the emphasis to be on the narrative. The primitive addressed comparisons between "high" and "low art."

NARRATIVE TEXT PAGE 79, FIG. 13 THROUGH 16, PLATES 30 THROUGH 35.

WHY BE NAÏVE?

The idea of primitivism in modern art arose as a rejection of the prevailing early twentieth-century culture. This rejection came after the impressionist movement. The impressionist artists made their art in the spirit of the prevailing culture; they were artists among many who wanted academic and institutional recognition. They saw themselves like Vasari did: that art reflects or corresponds via medium and color to some scene in the real world. The impressionist inventions regarding colors of shadows belonged to the same progress as linear perspective, aerial perspective, and chiaroscuro.

Modernism evolved when artists felt they could no longer belong to the entire pre-modern tradition. To be modern was to reject one's own cultural institutions and history. Art history provided examples of what not to do. [51] The modernist intention was to invent new prime objects or paradigms that would eclipse the styles and forms of the past. Artists in the early twentieth century looked to other cultures for a way to abandon the prevailing decorative, highly wrought "bourgeoisie" aesthetic. Establishing a direct and primal approach to expression and an aversion to the beautiful for its own sake became part of the modernist canon that passed from the early practioners through the ash can school, abstract expressionism, minimalism, and conceptual art. In this spirit, I used simple wooden sticks, paper, canvas and a stencil process of painting to create *The Entourage*.

These background influences, coupled with the desire to oppose the prevailing conceptual and minimal influences of the time, were my inspiration for making narrative installations. Rather than an approach of reducing and distilling, I took an opposite approach to the modernist history of erasures. I decided on an approach that added and layered concepts and media that broke down defining genres such as painting and sculpture.

THE NEA FOUR

Modernism is also the history of a progression of events steadily expanding, pushing against, and reconsidering definitions of the boundaries of art. Many artists are of the opinion that to be a modern artist or an avant-garde artist, one needs to find and then transgress a boundary. For example, consider nudity and eroticism in re-

lation to standards of social decency from the mid-nineteenth century to today. In the mid-nineteenth century *The Greek Slave*, a very demure and restrained marble statue by Hiram Powers, was exhibited at a number of American venues. When shown in Cincinnati, separate viewing hours were organized when women could study the statue without men present.[52] After creating his second nude statue, Eve, Powers wrote, "Eve might shock the sensibilities of many who found the Slave quite as much as their moral feelings could bear, for Eve is quite 'naked' and she does not appear in the least 'Ashamed'."[53] During the same period, the painter Thomas Eakins depicted the nude figure and sparked considerable controversy by offending the Victorian mores of the day. In the United States, this was the beginning of redefining what was acceptable in art with regards to nudity and eroticism.

In the 1920s and 1930s, the sculptor Gaston Lachaise sought to depict a kind of earth mother or fertility goddess. These are grotesquely over-proportioned nude figures which stand proud and strong. In a *New Yorker* profile, Gilbert Seldes remarked, "Each year the people who were terrified by the fatness or the largeness of the old figure look at the new one and say that the old one was monumental and perfectly proportioned and beautiful, but that the new one is excessive and 'indecently fat'."[54] Today, a large Lachaise sculpture can be seen in MoMA's sculpture garden. After observing the paucity of its present audience, it is obvious that its ability to provoke has long passed. The evolving and relaxing of mores is apparent in the "body art" performances that began in the mid 1960s. For various reasons or causes such as feminism, gay rights, eroticism, or simply to introduce deviant behavior into the context of art, artists began exhibiting themselves during art performances. These artists appeared naked, sometimes smeared with various substances, sometimes masturbating in public. The rationale may have been for some of these acts to reference ancient rites for which the nude body is marked by pigments in ritualized ways. For political reasons, the most notable of these artists were probably the

"NEA Four." In the late 1980s these four artists received grants from the National Endowment for the Arts to stage performances of artworks. When the decidedly political and sexually explicit performances came to the attention of Republican Senator Jesse Helms, he and many other politicians called for the abolition of the NEA. This led the NEA to defer approval of all performance grants. The "NEA Four" filed a lawsuit for violation of their First Amendment right of freedom of expression. It took eight years for the lawsuit to work its way to the Supreme Court, which decided that the NEA's decision to write in a decency clause "does not, on its face, impermissibly infringe on First or Fifth Amendment rights."[55]

Thus, the "NEA Four" lost their case and the NEA put in place rules recommending the restriction of free speech. Supporters and critics asserting their views regarding freedom of speech, egocentrism, hyperbole, political causes, and pornography paid considerable attention to these proceedings. The NEA's new rules made it more difficult for individual artists to receive grants and the "NEA Four" achieved notoriety for the case and the feminist and gender issues championed.

As we see from the examples of Hiram Powers and the "NEA Four," the twentieth century was a time when artists continued to progressively push the boundaries of cultural decency. In order for these boundaries to expand, these exhibits or "exposures" were institutionalized through sanctioned exhibits in art venues and by the press. As these "exposures" continued through the years, they became increasingly literal. A parallel can be seen in the entertainment industry's current graphic crop of "Porn Torture" films and more and more realistic digital war games. The common denominator is not, of course, the content or the audience, but the literalness of it all. In terms of the literal extreme of sexual exposure for art's sake, it is difficult to imagine a more graphic line being crossed than when in 2005 an artist copulated with an art collector and presented the documentation of the event as an artwork in a gallery exhibition. This seems the likely endgame for artists inclined to

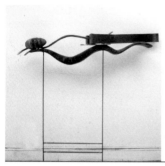

FIG. 17. *Two Whys and a Q,* 1991, wood, steel, wax, lead, silver leaf, stain, 56"x50"x20".

titillate for attention.

Since Piero Manzoni canned feces (1961), contemporary art history has well established that vulgarity is another viable expression for artists. By years of over-exposure, the contemporary bourgeoisie is inured by artists' efforts to cross perceived boundaries of decency. As a contemporary art strategy, it is now an exercise in banality. For these reasons, I reject certain artists who employ strategies merely to insult, such as defiling dead animals, smearing Santa Clauses, and flaunting penis noses. Demonstrations similar to these examples are now nothing but a juvenile bid for attention.

TWO WHYS AND A Q

At the time of the commotion stirred up by the "NEA Four" and Senator Helms, I decided to demonstrate that erotic subject matter could be expressed in art without being base, literal, vulgar, or even censored. *Two Whys and a Q* is a sculpture signifying two people asking the question of intercourse. Perched upon metal legs is a carved wooden form representing an undulating bed, stained blue like rushing waves of the sea. A bulky heavy masculine "Y" covered with lead and a sinuous feminine wood "Y" lie on the bed, their stems spread, touching one another. Placed between them is a jewel-like "Q" covered in silver leaf representing the vagina, the subject of the question. Balanced on the bed, to be given or taken, is a seed or head made from wax and lead. Placed upon one another and held by gravity, these pieces appear as if they might at any moment move. **FIG. 17, PLATES 36 AND 37.**

ART AS SPECTACLE

In the early 1980s, I attended an art installation by Dennis Oppenheim. It was a whirligig sculptural contraption sprawled out in the center of a gallery in SoHo, New York City. It seemed that every armature was affixed with fireworks. I stood by the door on Wooster Street just in case he was going to light the fireworks. And he did. Wiz, bang, swoosh went skyrockets and flares. Everybody in the front of the gallery ran out the door. Everyone in the back hit the floor. The place filled up with smoke. Sirens wailed, fire trucks pulled up, and water added to the mess in the gallery. Dennis was last seen running down Wooster Street. The sculpture was in ruin as was the art gallery. The opening was over, roped off by the firemen. Although the artist was long gone, I thought this was as good a definition of art as spectacle as can be. It is certainly inappropriate to endanger the public with fireworks but it is a good example in the history of artists' efforts to affront good taste. Yet, this particular spectacle did not measure up to the bad taste that is demonstrated by the German provocateur Hermann Nitsch.

THE NASTIES AND THE BAD TASTERS

The key issue for provocateurs and performance artists concerns the nature of the connection the artist makes with the audience. A convincing performance would be one that evokes empathy or a catharsis with the viewers. This type of connection between artist and audience transcends meanings conveyed by the artists' ego and the audience's otherness. An unconvincing performance would be a didactic one or a demonstration. Here the audience is left to observe on the outside. Due to this disconnection the artist's actions become self-referential and egotistical. The content of the work may be pertinent regarding art, racism, sexism, or all of it, but depending on the degree of disconnection from the viewer, it becomes primarily reflective of the self-centeredness of the artist.

Like a disaster, art spectacles may call for our attention, but that does not necessarily make them a redeeming experience. An insult to the senses is not a catharsis. Hermann Nitsch may be the epitome of the indulgence of the artist in his ego at the expense of the audience. In describing Nitsch's performances, Thomas McEvilley observes that "… performers tear apart and disembowel a lamb, kid, or bull, cover themselves and the environment with the blood and gore, pour the entrails and blood over one another, and so on." [56]

McEvilley refers to a ritual sourced in Antiquity for an explanation, "In form they (these performances) are essential revivals of the Dionysian ritual called the sparagm, or dismemberments, in which the initiates . . . tore apart and ate a raw goat that represented the god Dionysus." [57] It may be hard for some to tear their eyes from the disembowelment of a goat, beyond that stare I question such sacrifice as being able to achieve an empathy or catharsis in our time as it did in Antiquity. If, as I expect, the viewer is alienated from such a spectacle then the act is performed in the name of theater, art, and the artist's ego.

Beginning with Van Gogh's ear there are many contemporary examples of artist's acts of self-mutilation and otherwise. I remember another took place in 1977. An artist performed art provocation and protest on top of the *SoHo Weekly News's* art critic's desk. At the time, the newspaper was an influential arbiter of taste in the downtown New York art scene. The artist burst into the newsroom, put his hand on the critic's desk, and lopped off a finger with an ax. Ultimately the question to consider is not if these acts are art, but rather if they are expressions of mental illness.

THE AMERICAN DREAM

Recently, driving the back roads of upstate New York, I happened to come up behind a back-loading tractor with its scoop piled high with dead deer. It was quite an image of carnage to see all those victims of road kill. While following the truck I was inspired by an idea to parody the "Nasty Artists." Road kill is a familiar sight of upstate back roads. The woods harbor white-tailed deer, raccoons, striped skunks, river otters, possums, weasels, fishers (related to the weasel), moles, beavers, and fox as well as many squirrels and chipmunks. All of theses creatures along with occasional dogs and house cats can be spotted smashed on the winding roads of the Catskill Mountains.

It occurred to me that if I were a "Nasty Artist," I might gather up these wrung necks, limbs akimbo, splayed bellies, spilled guts, and squashed heads and scatter them about on the floor of a downtown art gallery. A white stripe would be painted on the center of the gallery floor, signifying the center of the road. The invitation or poster for the spectacle would show a 1956 Chevrolet Thunderbird sports car drawn in the iconic 1950s illustration style. Standing beside the car would be an illustration of a Vanna White-type beauty in period fashion presenting the car with an outstretched arm. The exhibition's title would be *The American Dream*. The gallery goers could witness the road kill rot; in a month maggots would surely eat flesh. This, I thought, would be my bid to rival the most "nasty" of gestures I have known artists to make. I don't need to realize this idea the satire is enough.

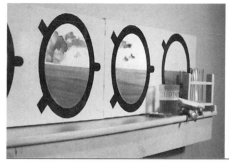

FIG. 18.
The Scientist and the Sea,1978,
installation detail, wood,
photostats, acrylic paint,
acrylic, fish, bread, glass,
dimensions variable.

FIG.19.
Wake Up It's Time To Go To Work, 1980,
installation view, wood, steel,
paper, plastic, lights, tar,
oil paint, rubber,
dimensions variable.

THE SCIENTIST AND THE SEA

In 1979, I did create an installation that was my best attempt at being "nasty." Exhibited at P.S.1, *The Scientist and the Sea* was loosely based on Darwin and his ship, the Beagle. Prints on boxes were mounted upon shelves running the length of the walls. The prints depicted the portals of ships revealing the sea through the portals. These prints were done in the style of a children's coloring book. Designing a coloring book, printing it and coloring it was an intentional gesture of naiveté and a commentary on the tradition of painting. The narrative of the tale began with an old photo of a scientist who hoped to discover how creatures worked. The installation ran like a sentence, left to right. Next were microscopic images of an amoeba and microscopic sea creatures. From the portals sea creatures could be seen jumping. At the end of the installation, it was time for lunch, so beer and a sardine sandwich were set for the scientist. The first bite of the sandwich took off the heads off the little fish, allowing for the guts to run out. The contrast between the fish sandwich and the children's drawings was my best effort at intentional "bad taste." I thought the contrast would create a disturbing gesture, but in reality, it wasn't as insulting as it was humorous; people laughed. **FIG. 18, PLATES 38 THROUGH 46.**

WHEN ANTI-ART AND BAD TASTE ARE ASSIMILATED, THEN WHAT?

In the spring of 2007, I attended a New York University panel discussion called something like "What is it to be radical today?" It struck me that the cognoscenti would still consider that a relevant topic to discuss. What boundaries were there left to break? Radicalism requires boundaries to break. The dadaists were radical when their acts of irrationality and cynicism rejected the then accepted norms of beauty and society. Closer to us today, Vito Acconci was radical when in 1970 he stuffed his hand down his throat and called it an art performance. This act of radical art was done in order to break down perceived institutional and theoretical boundaries of "acceptable" art. In the 1970s, performance, conceptual, and minimal art addressed these boundaries by crossing and expanding them. By 1980, these once radical acts, thoughts, and installations became accepted, institutionalized, exhibited in galleries and museums, bought and sold. They succeeded in promoting their theories and became part of the art historical record. When radical acts become institutionally accepted as legitimate art, they can no longer be considered radical.

An inversion has occurred. Strategies of rebellion have become conventional. What was once perceived to be radical acts are now academic. To assume conventional and traditional artistic definitions is now to be radical. It took a hundred years to go full circle. All that's left for the "traditional" radical artist is cultural taboos, such as religion or illegalities.

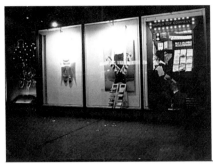

FIG. 20.
World Toy Company, 1981,
wood, paper, plastic, lights,
photostats, cloth, oil paint, rubber, plaster,
miscellaneous objects, 240" x 100" x 36".

WAKE UP IT'S TIME TO GO TO WORK

Having made an attempt to create art in "bad taste," I thought to elevate my intentions, so I turned to express social, economic, and political content. I took up the plight of the working class and obliquely, a critique of corporate culture. *Wake Up It's Time to Go to Work* was an installation at Artist's Space in New York City in 1980. It critiqued the injustices of our system of economic rewards. I took inspiration from Jean Millet's 1857 painting, *The Gleaners*. The painting shows peasants gathering the wheat that was left after the fields had been cleared by the landowners. I took this theme and reworked it sculpturally, using baskets filled disproportionately with gatherings of saddle-shaped forms made from tin and paper. The baskets were suspended from the ceiling and represented a currency or a crop of an odd kind. The rows of baskets led to a tar-covered ramp-pyramid sculpture. I thought of Sisyphus pushing a rock uphill, only to have it roll back down again. So, illustratively, while the tar was still wet, I ran up the ramp and slid down through the tar, giving the sculpture a "human touch." Facing this "mountain" on the opposite wall hung a decidedly low-technological, industrial looking stock market electrical reader-board. Instead of stock symbols passing left to right lunch bags, with their sandwiches falling out passed along a conveyer belt. On the face of each bag, in place of the workers name was "again, again, again": a pun comparing the workers' repetitive jobs with a

stockbroker's financial gain ("a gain"). The installation included a number of clock objects stuck on nine (time to go to work). A large photo of a newly opened ethanol plant addressed the future fossil fuel crisis. The intention of this installation was to draw attention to the unequal distribution of wealth under capitalism as well as corporate and government wisdom regarding energy investment.

However, the form exhibited was not literal, it was not comprised of easily interpreted signifiers. The form associated with meanings that needed to be deciphered by the viewer. In this way, the installation was evocative. The form evoked certain associations: the baskets could be carried, some had more "potato-chip" shapes in them than others, the constructions expressed a labor's hand, and so on. The form allowed the viewer to interpret these meanings. Also, the enveloping floor to ceiling installation and the smell of tar provided a visceral experience for the viewer. **FIG.19, PLATES 47 THROUGH 55.**

WORLD TOY COMPANY

I continued my social critique with a project that satirized popular culture and consumerism. *The World Toy Company* made appearances at a number of different venues. It was first installed in the New Museum's special exhibits display windows on 5th Avenue and 14th Street, in New York City, in 1981. At the time, vendors sold

various inexpensive goods on the 14th Street sidewalk. I mirrored this real marketplace with the "World Toy" metaphor. I divided the installation facing 14th Street into four sections correlating to the structure of the display windows. The first section was a "kiosk," a booth set up to sell the toys produced by *The World Toy Company.* Each toy had a different theme. They were mental puzzles, conundrums, puns, and satires intended to amuse and poke fun at consumerism. The second and third sections showed figures representing consumers titled *The Deciding Man Could Not Decide* and *The Deciding Woman Could Not Decide, Which Accoutrement?* Symbolically, the figures held two accoutrements, identical to one another, in their left and right hands. The Deciding Man held "red flap briefcases" and The Deciding Woman "held purses of coals (to light my fire)." The fourth window displayed transparent plastic male and female figures frozen in a leaping state of yearning. Together, they floated over the world to reach for what they could not attain. The display addressed the concept of marketing that is intended to keep the consumer in a constant state of yearning for the unattainable. Above the leaping figures floated a cornucopia, all lit by a starry sky. **FIG. 20, PLATES 56 THROUGH 69.**

Having realized the spirit of "World Toy" via the form of "display window art," I thought to reinterpret this irony and satire through the traditional medium of painting. Borrowing the "pop art" strategy of using the form of painting to ironically present literal content, I created satirical versions of "pulp fiction" book covers. One example of the series is titled, *Pulp Fiction, Too Expensive Not Good Enough.* **PLATES 70 THROUGH 78.**

The spirit of "World Toy" appeared again at a benefit for the New Museum on the occasion of its move to SoHo in 1983. Inspired by the hot dog carts in Central Park, I took my art cart to Broadway, stacked with my saddle shaped wares, stopped commercial feigning, and became "For Sale." **PLATES 79 AND 80.**

POLITICAL ART SERVES THE CONTENT

To be successful as a political artist the artwork must communicate to as many people as possible. In order for the work to be easily interpreted, it must literal. My primary attention concerning the project *Wake Up It's Time to Go to Work,* was to make idiosyncratic forms within the new genre of "installation art." Readability was a secondary concern. Using political content was a way for me to address political and social content in addition to contextual art issues. I saw political art as one way to address something larger than art theory. The problem of political art is that it must be literal, the form must be descriptive, in order to advance its agenda. The murals of Diego Rivera illustrate this problem. In the 1930s, he was asked to create a large mural for Rockefeller Center in New York City. Midway through, the project was cancelled due to the literal socialist content he was depicting, particularly his portrayal of Lenin on a monument to capitalism. Certainly, this had a powerful content, but I believe the success of his art did not depend on its literalness; it was powerful because it was formally and latently compelling. Literalness does not in itself make for successful expression. For political art, as well as other genres of art to be lasting, the form must surpass the content in its significance.

Consider another example, Rodin's *Burghers of Calais.* Eustache de Saint-Pierre, a hero of the Hundred Years' War, had allowed himself to be taken hostage by King Edward of England in 1347. Eustache's bravery during the English siege inspired others to surrender, thus saving the citizens of Calais from starvation. The town was at King Edward's mercy. Following the recommendation of his advisors, the King showed mercy and took just six citizens. He ordered them to have their feet and heads bare, wear halters around their necks, and carry the keys of the town. The richest man in town, Eustache de Saint-Pierre, was the first to step forward and five others then followed. **PLATE 83.**

Another example is Théodore Géricault's 1819 painting, *Raft of the Medusa.*

In 1816, a government frigate, the Medusa, was wrecked on a voyage to Africa. The ropes of a raft, to be towed by lifeboats, broke, and the float drifted off, carrying 150 men. Suffering with hunger and thirst, fighting one with another, they were eventually sighted after twelve days; only fifteen were rescued, some near death. The disaster caused a great stir. The government was accused of having appointed as captain an inefficient favorite, and necessary means for safety had not been provided. The case was taken up by the liberal opposition (to the government) and Géricault joined in wholeheartedly." **58** The form of the painting is as dramatic as the event, the canvas is composed of two dynamic pyramid shapes; one a cascade of bodies the other a mast and sail. All of the paintings compositional angles oppose one another and the light and dark value spans the spectrum. Both of these examples are secular, I suggest, if not for the artworks convincing form these stories may have easily been forgotten in history.

Unlike secular art the content of religious art for the most part dominates the form of the art; the story greater than the image. One exception may be the 1637–1639 painting by Francisco de Zurbarán, *The Battle between Christians and Moors at El Sotillo*. In 1370 the Spanish forces were saved from a night ambush when a miraculous light revealed the hidden Moorish troops. If not for this painting, prominently displayed in the Metropolitan Museum of Art, the event may be lost in history. **PLATE 84.**

Knowing the events that inspired these artworks reveals to us their political and social content. However, we do not need to be familiar with the history of the subject in order to appreciate the power of the form. The form rises above the story. Compelling form keeps stories alive. If not embodied in convincing form, these events may have been lost in time. Heavy handed, literal, and didactic content coupled with weak form makes for problematic art. Weak form occurs today in much social, political, and neo-conceptual issue-driven art. If form is the value that will be artistically lasting, then art inspired primarily by didactic language will be readily eclipsed.

NO MORE IRONY

Reflecting on the "World Toy" project, it occurred to me that irony is not a courageous form of expression. No faux "World Toy" products worked; they satirized themselves and consumers who, ironically, were actually buying cheaply made products from sidewalk stands outside the art show display window. Irony and satire are wit and criticism with the intention to ridicule. By belittling its subject, satire's recommendation for improvement is in a negative spirit. The method of irony and satire call attention to themselves, which allows the artist the distance necessary to enable a fashionable lure.

In our popular culture, irony becomes a synonym for cool, for cynicism, for detachment and pseudo-intelligence. This isn't irony as traditionally defined; rather, it is a new post-modern irony. Its use demonstrates that the concept of art as an authentic creative inquiry is defunct. Irony is self-referential; it signifies that there is an absence of authenticity, or emotion of any kind, thus it rules out the existence of truth or moral certainty. Post-modern irony is not used to puncture prevailing fraudulent cultural conventions but to undermine the notion of sincerity altogether. Thus, it becomes the sister of cynicism. For example, the expressions of the ironic artist might be interpreted as, "I am not saying what you think I am saying, but I am not saying its opposite, either." In fact, what I am "saying" doesn't necessarily mean anything. What is really interesting is the "me doing the saying." The sum of this post-modern irony is that the artist avoids taking a stance altogether. The position is a cover, the artist attempts only to provide for the audience by surface effects and titillation, a lure, and the sheen of glamour. Its modus operandi is to turn irony upon itself, to say, "my irony is ironical." This scarcity of commitment defines superficiality.

Many years ago, I viewed flatly painted monochromatic panels on a small scale. I saw them as versions of minimalist painting, but then I found they were re-

FIG. 21.
When What Place, 1984,
installation detail, wood, acrylic mirrors, lights, oil paint,
clocks, steel, dimensions variable.

paintings of paint store swatches, a presentation of a color scheme for the walls of a hospital in New Jersey. This was a satire of the seriousness of purpose expressed by the genre of minimalist painting. I remember this work not because of its significance, but because I was told, while looking at it, that this young artist had recently died. I thought how sad this slight expression, merely a satire addressing art theory.

The first generation of minimalists and abstract expressionists were honest and authentic in their endeavor. Theirs was a positive and a courageous position, not cloaked by the remove offered by irony and satire. These artists not only advanced the premise of what art could be, but also at times, offered through elegance and serenity, expressions of transcendent meditations, a sentiment impossible to achieve through irony and satire. Satire and irony represent a kind of fear. Our contemporary popular culture is laced with this flippancy, coldness, and inhibition. I decided this was not the method I wanted to use, so I stopped with satire and irony.

WHEN WHAT PLACE

I thought enough of the little ideas. I returned to tap inspirations that inspired the earlier projects *The Entourage and When Creatures Crawled From the Bowels of the Earth*. These were large metaphors addressing life and art. *When What Place* was an installation of sculpture, painting, lights, clocks, and text that synthesized art genres.

With a dose of humor I chose to create an art installation that expressed the "biggest" idea I could think of: the universe, including time and space.

A ten by twenty foot canvas represented the celestial expanse. The solar system had popped out of the painting to stand upon the floor. Pictorial space became physical space. Mercury, Venus, Earth, Mars, Jupiter, Saturn, Uranus, Neptune, and Pluto left behind holes in the night sky. Each planet became an animated head upon legs. Clocks on the wall ran backwards, for time on each planet is different. All the forms echoed the text: "Black hole, hello below, twirl of time, clock of paintings, sunshine. Altogether our time, you and the universe passing a place, mirror mirroring the viewer in time and space." **FIG. 21, PLATES 83 THROUGH 86.**

DISPLAY ART

The 1980s witnessed an array of styles; most notably a neo-expressionist painting style and a neo-conceptual pop art style that I choose to call "display art." Display art was anything but traditional; it employed manufactured gadgets, words, corporate logos, and images and objects appropriated from popular culture. Most of this art was highly produced, manufactured, hid emotion and the expressive hand of the artist. For the most part, the content was literal, the form expressive, high key, ironic, satirical, and easy to read. These image and object makers swung the pendulum of

anti-aesthetics back from a minimalist reductivist denial to visual excess. The work was visually abundant, yet remained distanced and cool. Display art countered the big splashy paintings of the neo-expressionists. After the critical degeneration of the genre of painting throughout the 1970s, I was surprised to see and experience the celebratory return of neo-expressionist painting. It signaled that the time of a critical hegemony, a dominant idiom, was over. Minimalism and pure conceptualism had been eclipsed as a dominant influence.

Painting emphasizing irony dismissed serious criticism. Pop art was resurgent as "display art." Taken as a whole, the 1980s were an uninhibited, postmodern collage of ideas and images. Some of it was socially critical, but much of it seemed like intentionally ambiguous visual indulgence. This time seemed to exclaim that there would never again be an irrefutable way, a theory to follow, or hegemony of style.

DEALER SHOWS HIS HAND

During the 1980s, I made wall reliefs and installations employing various commercial materials and production techniques. I thought this new genre of "display art" was a way to move beyond traditional definitions of painting and sculpture. The *World Toy Company* and *When What Place* are examples completed early in the

decade. Following these projects, I improved my production techniques. My new works were constructed like cabinetry. According to need, they were spray-painted in bright flat colors and cast in resin and marble dust. I had plastic vacuum pressed over molds and executed gold leaf and lead applications. Electricity added light to the displays. Much of the work was subcontracted. Unlike most display art of this time, my layered constructions were not literal; they were not a quick read. They required decoding. However, in keeping with the emotional and visceral distance common to the genre, I eliminated the touch of the hand. In doing so, I thought to eliminate self-referential, personal content. By aligning with processed popular culture, this approach to art making eliminated the notion of the "angst ridden solitary artist in a garret." Addressing political content complimented the visual distance of the works' cool surfaces. I thought political content was appropriate, as it was at the height of the Cold War, between Reagan's 1982 "evil empire" declaration and before the Berlin Wall fell in 1989.

The concept inspiring *Dealer Shows His Hand* was a cold war poker game. The card players were Russia, China, and the United States. The bright three-dimensional constructions presented the countries as gamblers. The wall sculptures, intended to face one another, included shields stenciled with patterns of people running. The "gamblers" sowed flags upon which were sewn maps representing the

[43

Kremlin for Russia and The Forbidden City for China. All could see by the mirrored heads the cards the players held closely. The series was also an allusion to relationships between art dealer, patron, and artist. I continued this political commentary by the means of a large wall relief, *How the World Turns*. The five continents were set upon large black gears. Yellow geometries representing political and economic problems blocked the continents attempts to mesh. Another piece titled *A Close Shave for Both of Us*, personalized the idea of danger. The works expressed political and economic observations rather than recommendations. **FIG. 22, PLATES 87 THROUGH 90.**

MY REASON TO REJECT POLITICAL ART

Of all my political artworks, I thought *How the World Turns* was the most literal and for that reason, successful. It was a large, easy to decipher three-dimensional graphic. Political art is driven by an agenda; therefore communication is its most important criteria. It occurred to me that that a political agenda would best be served by activism. The time one spent actively advancing a cause would be more valuable; more might be achieved than time spent making art. Communication as an activist would be greater and dialogue more direct. In addition to these thoughts I felt that political art presented to the art cognoscenti is like the old adage, "preaching to the choir." By these reflections I realized I was making art for a "cause" because I thought in more noble than art addressing popular culture, fashion or art theories. I came to understand my political "cause" sprung from a reaction to art culture, not politics. In addition, I realized that political content, by its nature, is temporary. *The Dealer Shows His Hand* addressed the Cold War. The Cold War is over. Artists can be clever addressing the moment's cultural hot buttons. This approach is a strategy, not a vision.

ART OF THE QUICK READ

The layered relationships between the formal elements and associations comprising my "display art" efforts offered an alternative to "quick read," or "walk by" art. The examples of pop art and minimal art established the idea of an artwork as a single statement for ready consumption. The opportunity for the quick read allowed for easy identification of issues outside the art object itself. These issues primarily addressed contextual and cultural issues relating to artwork. This made it easy to enter in discourse as well as to peruse the gallery scene. With a bit of art experience, one could understand almost everything at a glance, put it in its contextual place, and move on to the next thing. I thought this approach, regardless of the style, not to be conductive to contemplation or reflection. With this in mind, I moved toward the idea that art should hold a gaze, provide something to ponder, decipher, or become a meditation. In this way, the work could be self-referential. Unlike pop, minimal, and neo-conceptual art, I wanted my work not to primarily reference the context of art or the cultural discourse of the moment, but rather have the content embedded. References are not possible to avoid, but I thought to make my work self-referential as much as possible. There are an abundance of earlier models for this kind of art. Mark Rothko and Alberto Giacometti are two who come to mind.

At a time when the discourse about art was fracturing, splintering into niches, I thought a way past art referencing was through the genre of installation art which sourced multiple genres (painting, sculpture, photography, etc.), thus neutralizing issues regarding all of them. By adding a narrative content, I hoped the experience of the artwork would transcend the contextual issue surrounding art altogether. In this way I was trying to find a way to express the idea of "embedded content."

FACSIMILE ART

Today clever art is about the structure of the way art is talked about rather than made. And that influences everything. Even where it seems someone is taking an aesthetic approach nowadys, the structure of the thought is really the theme.

Matthew Collings [59]

"Facsimile art" is art once removed, an art alias, a sign that signifies the idea of art. It is as if the artwork says, "If I were art, I would look like this." Unlike Duchamp's readymades that attempted to establish a position outside a definition of art, facsimile art assumes the precepts of an art form and then attempts to deny those precepts. For example, consider the arc of Barnett Newman's career. In addressing the use of ambiguous forms expressive of metaphoric signs, Newman, in the early 1940s, said, "The present painter is concerned not with his own feelings or with the mystery of his own personality but with penetration into the world-mystery. His imagination is therefore attempting to dig into metaphysical secrets." [60] "The new painter is in the position of the primitive artist, always face to face with the mystery of life, always more concerned with presenting its wonder, his terror before it, or the majesty of its forces, rather than plastic qualities of surface, textures, etc." [61]

These statements addressed a period of post-surrealist works by Newman, Rothko, and others that were evocative of ambiguous symbols and biomorphic shapes. In 1948, Newman began with *Onement 1* to create his signature "zip" paintings. Many times, the so-called "zip" gesture were a single line defining the spatial structure of his paintings. This formal device has been considered by many to be the last "breakthrough" in the history of painting. During this period his paintings became more and more formally and expressionistically reductive. Critic Max Kozloff regarded Newman's late paintings as excessively reductive, lacking even the interest of well-developed formal relations. [62]

Newman's late works were still essentially considered painting because they retained the convention of paint on canvas over stretcher bars, but nearly all other attributes common to the discipline of painting were erased. His progress followed the arc of the "modern art" narrative. The problem with this reductive progress was not that his works could no longer be considered paintings, but that external associations or content disappeared. Newman's artworks were no longer about the deep subconscious or felt experience; rather, they were only about art theory. Other than scale, the paintings were nearly not there at all. Thus, they became primarily a contextual commentary. Since Newman himself was a great talker and ever present on the cultural scene, he became enmeshed in the cultural discourse of the time. The artwork itself evolved from noble beginnings, but ended up aesthetically banal, a facsimile of painting.

The concept of "cultural discourse" surrounding art includes the press, the critics, the patrons and the institutional attention bestowed (in other words, the buzz of the moment). Andy Warhol gives us another example of the cultural discourse becoming more significant than the artwork itself. Yves Klein and Piero Manzoni established precedents for being provocateurs who presented devalued art objects. Warhol continued this tradition throughout much of his career. His flower painting series are a good example of aesthetic banality. Andy Warhol's flowers were based on a color photograph of hibiscus blossoms taken by Patricia Caulfield that appeared in the June 1964 issue of *Modern Photography* magazine. When Caulfield saw Warhol's Flower paintings, she brought a lawsuit against the artist, and a cash settlement was arranged. The Flower paintings showed a clichéd subject matter, the images were flat and symmetrical, and the style was intentionally technically inept. Like Newman's paintings, Warhol's paintings could not be defined as other than paintings, but nearly all other redeeming attributes common to the painting tradition were eliminated. Even the fact that the source, the Caufield photograph, was

appropriated ran counter to the traditional notion of "creativity." [63]

Warhol, like Newman, was a fixture in the art scene, and both became mainstays in the cultural discourse of the day. Their persona as well became synonymous with the art object. Warhol, ultimately, was more successful, and probably more self-conscious than Newman in acting out this strategy. This "blending" of the artist's personality within the cultural discourse effectively relegated the art object to a secondary role. This reduction of the artwork's stature effectively turned it into sign, an "alias," a facsimile of itself. Arguably, this innovation is Warhol's greatest contribution to the history of art.

There are countless ways to critique painting and the careers of artists. Newman's point of view during the early 1940s was that the art of painting should address the "mystery of life" and be an expression of a genuinely felt aesthetic sensibility. Inherent within this view is that painting also show the visceral experience of the painterly medium itself. If we consider Newman's point of view as the definition of the art of painting, disregarding other considerations such as contextual art issues, irony, satire, commodification, and celebrity, then Newman who began with a humanistic, transcendent vision, came to betray these ideals by formalistic banality. Newman's late work addressed primarily formal and art contextual issues yet he continued to believe they were transcendent. This unknowing negation of his earlier ideals marked the end of his career with a sense of tragedy. If Newman is tragic then Warhol, by assuming the form of painting and feigning its aforementioned qualities, by intending banality beginning to end, and by exalting in his art as a business, is a farce.

One cannot deny that Warhol is the source, the figurehead of moving the art world zeitgeist from the idea of art as having a humanistic seriousness of purpose to a paradigm recommending kitsch, commodification, and celebrity worship. Warhol's success blended the notion of high art with marketing and popular entertainment. His contribution has been a dominating factor for more than thirty years, and I expect, considering the nature of our culture, it will continue. In this environment, art that has a seriousness of purpose and bespeaks of the human soul, will continue primarily through a self-aware fellowship of artists and arbiters. There will be no membership cards, no styles or "isms." Kindred spirit will be acknowledged through their expressions.

LIMPLY VISUAL

The apologia for art that deliberately fails visually is that it challenges aestheticism. It is true that aestheticism can be academic and predictable. But now the limply visual is an academy in itself.

Matthew Collings [64]

Understanding the idea of anti-aesthetic art is rooted in an eclipsed narrative of modern art. This narrative means that notion of anti-aesthetics itself is a part of art history. When it is used today, it is done in a historical style. This is what Collings means when he equates the "limply visual" with the idea of the academy. Because anti-art is an academically institutionalized style that is ironically, as a theory and practice, no longer valid. As it is, the critical arbiters continue to give credence to the anti-artists, the "nasties" and appropriators. Given the historical precedents of the dynamic between provocateur artist, cultural discourse, and anti-art, it is apparent we are now in a vision rooted in the last dying breath of the notion of the avant-garde artist. We are in a time that continues to revisit styles; anti-art, dissolution and neo-conceptualism that are at an end. It is as if we are in a critical rewind, stuck in a loop. As Matthew Collings observed, "It's as if all the ramifications of a particular moment in art, the post-conceptual eureka, finally hit art criticism and criticism got it and then kept repeating it endlessly, so art goes on being about that moment forever." [65] The current state of "cultural discourse" appears to be stuck at the end

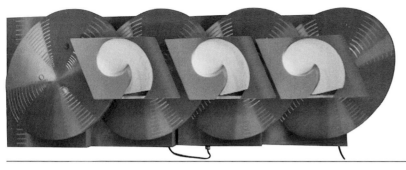

FIG. 23.
Passing Times, 1986, wood, oil paint, marble resin,
lights, electricity, clocks, plastic, 50"x132"x18".

of a paradigm. I propose to reintroduce what Duchamp and the dadaists intended to end. The way out of this cul-de-sac is a phenomenological appreciation of the physical world and the evocation of particular aesthetic sensibilities.

HOW ART CAN BE TRANSPOSED FROM ITSELF TO BECOME THE ARTIST AND THE VIEWER

Envision a "blue chip" gallery presenting a solo exhibition. Before entering the gallery, imagine that the name of a soon-to-be celebrity is flashing in lights over the entrance. The ironic and kitschy marquee enhances the artist in this fashionable post-modern time. For dramatic effect, the space is black. Inside, the viewer faces a gilded full-length mirror. The gilding suggests the importance of more kitsch. That's all that's needed. The exhibition provides the artist inclusion in the cultural discourse. The marquee provides the viewer with the announcement of the celebrity. The mirror provides the viewers the opportunity to experience a catharsis with themselves and by extension, the celebrity artists. The banality of the mirror allows for the importance usually attributed to the art object to become the purview of the viewer and the artist. By consuming the mirror, the viewer has the opportunity to experience notoriety and to become, with the artist, the subject of the art. The circle is complete. With this in mind I note the many mirrors and reflective surfaces that

appear in contemporary artwork. **FIG. 21.**

The relationships between artist's ego, the cultural discourse, the viewer and the art object is one of the most poignant issues in contemporary art today. To change the cultural drift from a critique driven by market and celebrity to an opposing paradigm is a challenge that can be met only by the fellowship of artists and cultural arbiters who understand the significance of particular aesthetic sensibilities has been lost in our post-modern culture.

PICTURING TIME

I reached my nadir in 1986. I was thirty-six years old. The last of a number of "display art" pieces I produced at the time, *Passing Times,* were large, bright, high key, colorfully saturated, slick, sequential wall reliefs. The works were a combination of painting and sculpture; they were dynamic compositions made from a variety of media including molded plastic, glowing lights, and moving clocks. The high quality production associated to the look of expensively made corporate displays. The difference was that corporate displays were promotional. Aside from the artist, *Passing Times* only promoted itself. Even though the works were high key, they were distant and unrevealing, I hide emotion and the touch of the expressive hand. The works had the look of luxury commodities. I wasn't trying to be ironic, but the

project came close to the look of kitsch. I had manufactured big gadgets intended to "wow" an audience at first glance.

Wake Up It's Time to Go To Work and The World Toy Company were installations and displays critiquing popular culture, consumerism, corporate culture, and capitalism. Passing Times seemed to have shed this critique. On the completion of the project this didn't occur to me. It took being endangered and physically shook up to reflect and reorient my artistic compass.

FIG. 23, PLATES 91 AND 92.

ALL THE TIMES I WAS MUGGED IN NEW YORK CITY

Being mugged is distressing and depressing. It lowers the spirit. It stops one in time and affords the opportunity to reflect upon the goals and the meaning of life. I was mugged four times in New York City during the 1970s and 1980s. On the aftermath of each mugging I was compelled to self-reflection. The year 1976 was the first time. I was twenty-six years old. A few years later, I was walking up 5th Avenue near 23rd Street on a warm spring evening. The setting sun cast long shadows upon the buildings, and I remember the beautiful light. I was under construction scaffolding, and suddenly I was looking down the barrel of a handgun. I said, "You don't need that," thinking this was not a movie. I promptly handed over my wallet. When the mugger left, I flagged down a police car and we followed in the direction he had run. Blocks away, I identified him and the police disarmed him. In a most surreal movement, I sat with my would-be assassin in the back seat of the patrol car on the way to the station house.

A couple of years later, I walked into my Williamsburg, Brooklyn, studio just after a robber had left. The guy had made a mess looking for valuables, but there was only art, so nothing had been stolen. What most irritated me was the happy face he spray-painted on my bed. After leaving my studio, he went upstairs and was promptly cornered by the Brooklyn boys who lived in the top floor apartment. I followed the opened doors to see the scoundrel at knifepoint awaiting the police.

The last time I was mugged was in 1986. I left my studio late one night to return to the city. Before going into the subway, I stopped to buy groceries at the deli near the Graham Street subway station. As I was entering the subway I was promptly pushed down the stairs from behind. The moment of falling seemed protracted. While in the air I was able to reach back, grab the crotch of my assailant, and squeeze his balls as hard as I could. Then, I crashed to the ground with the lout on top of me and my groceries crushed beneath me. Again I was separated from my wallet.

Lying at the bottom of the subway stairs in a pool of orange juice, I reflected upon what was I doing and what was meaningful, and all that came to mind was the question of "display art." The Preacher had principles, The Entourage, morale. Form evokes meanings. I realized the original reasons I was inspired to make art were long lost in these manufactured "display art" forms. This was my nadir, it had taken only seconds to fall down the stairs but years to hit bottom. It took a mugger to shake me up and to wake me up to the realization that I had compromised my vision in the effort to establish a career. I realized I had spent many years trying to be a part of a neo-conceptual pop art trend. This was art strategy. I was chasing the cultural "zeitgeist."

Eleven years earlier, I had gotten off the Greyhound bus at Times Square harboring the idea that art could express one's synthesis with nature, could be an expression of the spirit, or a transcendental truth. To me, "display art" seemed to hide behind manufactured edges, highly produced forms, superficial surfaces, decorative color, irony, and satire. I had eliminated an expression from my soul by turning to address entertainment, popular culture, cultural commentary, politics, and fashion. On the subway floor I realized I was making art intended for an audience, not for myself. This last mugging afforded me a pause. From this pause came the idea of a comma, which inspired my next project.

FIG. 24.
Figments of the Imagination, 1986, detail, wood, oil paint, fiberglass, lights, silver leaf, glass, paper, electricity, 40"x28"x18".

FIGMENTS OF THE IMAGINATION

In 1979 I rented a studio in Williamsburg, Brooklyn, for $170 a month. The studio was on the corner of Ainslie Street and Manhattan Avenue where the novel *A Tree Grows in Brooklyn* took place. My studio was a corner grocery store before I rented it, and it still had the counter. I was there, working on my artwork, most every night of the week and every weekend. Over the years I witnessed the infusion of artists gentrify Williamsburg. I kept that studio for more than twenty years.

Self-reflection and meditation allows for occurrences of insight and intuition. Many times the process of problem solving inhibits the opportunity for intuition. I had been making art that addressed particular issues. This approach of giving form to predetermined concepts is similar to problem solving. It occurred to me the idea of a comma was the pause that afforded the opportunity for art to follow intuition. This was a way to start again from another perspective. I thought to throw out my previous thinking process and begin again to rely solely on intuition. So I made a three-dimensional fiberglass comma the size of a head. It was a comma and a head. I called it "a cause to pause." From this I thought of the notion of a disembodied perspective. What if one was floating in space and could experience all perspectives at once, to have an omnipresent overview? What if intuition was all one

was? I made a cast fiberglass field of undulating space. I combined the comma heads alongside images of etched brains on glass. The heads floated over the field of space the brains were illuminated from within. They evoked the brightness of an idea emanating from space. I called the works *Figments of the Imagination*. One of the works embedded with numbers, referenced scientific calculations.

These constructions, combinations of painting and sculpture, were meditations in moody color and obscure points of reference. I thought they showed progress from the nadir I found myself during my time of addressing "display art."

Fiberglass is a wonderful material, but awfully toxic. Ignoring the danger to the family upstairs and myself, I neglected to ventilate the studio well. One night, my upstairs neighbors thought the building had a gas leak, and the fire engines wailed right to my door. My landlord strongly advised me to rectify the ventilation problem. The next day, I took my mold and medium out to the sidewalk and cast fiberglass in the open air. A woman came walking down the sidewalk, covered her nose, and angrily said, "Ventilate!" I replied, "How do I ventilate outside?" The landlord came by and complained that the run-off from the fiberglass was ruining his sidewalk. I assured him that it would wear off in a few years. This is when it occurred to me that art making should be easier. I decided it was too hard for it not to be a joy. **FIG. 24, PLATES 93 THROUGH 96.**

ACT FIRST THINK SECOND

I continued to reconsider my approach. I was aware that for most projects I established a textual concept first and then expressed it through form; the form followed the narrative. Over the years, I experimented with various styles to express the text; faux naïve *(The Entourage),* installation/performance *(Creatures Crawled From the Bowels of the Earth* and *Civic Plots),* high production display art *(Dealer Shows His Hand, Passing Times).* This approach began with a concept followed by a decision regarding style and then form. I felt it was necessary for art to address theory and history; therefore it needed to begin with a concept. An opposite premise would be art made without a preconceived structure of language. Could I act first and think second? I remembered *The Entourage.* The lesson of the mate was to act before being caught up in indecision. If art isn't driven by concepts, then it should be by the felt response of the artist to form. In order to work from this premise I felt I needed to try to let go of theoretical issues, stop analyzing and thinking about the audience. With this in mind I looked to make art through a direct means, simpler, subtler, and more expressive. This re-thinking or re-feeling took time to work through; it took many years to be able to trust intuition.

LATENT CONTENT, LITERAL CONTENT

> *Any object whatsoever, be it natural or artificial, can become a sign,*
> *provided that it is employed to communicate a message, i.e. to signify.*
> **John Sturrock [66]**

The evolution of modern art was a progression of critiques that assigned new meanings to form. For the most part, modern artists set out to create new forms that could not be defined by preconceived meanings. Ultimately, however, this was impossible since by the 1970s all form had been codified. As Arthur Danto said, "I suggest that it is no longer possible to present something as art without having it conjure up a reference." [67] When art became a sign, a signifier for language, there was no longer consideration of a synthesis between the aesthetics and ideas. Much of art was intended to represent a cause, such as politics, social critiques, popular culture, or philosophical inquires. Art immersed in semiotics is no longer able to evoke a heightened emotional awareness. From this state, art could no longer be an aesthetically transformative experience for the viewer. Regarding the condition of contemporary art the writer Robert Morgan said, "Desire was considered inferior to information." [68] Certain trends became theory blended into popular social discourse. No longer concerned with form, this art was an analysis, a deconstruction of social structures.

Assigning references to form is to make form signify certain meanings. Literal meanings can be deduced, regardless of whether the work appears figurative or abstract. Specific meanings assigned to form relate to given moments in time and to institutionalized definitions that have evolved throughout history. These historical definitions are preconceived assumptions that become part of the process of understanding new form. These meanings, contextually determined, are the "literal content" of the artwork. Pure form, shape, color, texture, composition, media, space, and scale express content intrinsically. This "latent content" provides the stimulus for intuition, associative thoughts, feelings, and memories of the artist and viewer. Latent content is essentially psychological and ambiguous. "Latent content" affords many different meanings that can be felt and interpreted, depending upon the experiences that determine one's points of view.

By contrast, "literal" content aims to communicate to the viewer the intentions of the maker, critic, or historian. For example, an illustrative painting such as a vase of flowers emphasizes literal content, defined as such by precedent. The colors and shapes are arranged to represent the appearance of a vase of flowers. The arrangement of these forms does not allow for any other possible interpretation. To

varying degrees, every artwork expresses "literal" and "latent" content. For example, political and popular art emphasizes "literal" content over "latent" in order to enable their message to be readily understood by an audience.

Initially, early modern abstract art emphasized "latent" over "literal" content to express, among other meanings, ambiguity and the unconscious. Subsequently, art history gave abstraction a layer of "literal" content by assigning meanings to the various abstract styles. Assigning meaning to previously non-referential form provides a sign system equal to the sign system inherent in the illustrative methods of "literal content." Assigning specific meanings to pure form transforms "latent content" into "literal content."

"Literal content" is language, it is understood through symbols held in the conscious mind. "Latent content" taps emotions and the subconscious. It is understood through feelings responding to form. The raison d'être of cultural critics, historians, and academics is to transform "latent content" into "literal content." These arbiters assign words to feelings. This sublimates the visceral response.

The inclination to make content literal in artwork is to enable easy interpretation. Art that is a "quick read" encourages cultural discourse, which essentially transforms form into words. Literalness serves to hasten and specify sign-sourced meaning. When literal content is emphasized, pure form as an expression "in itself" is compromised. In contrast, one can choose to emphasize "latent content" with a formal sensitivity to the emotion that can emanate phenomenologically from ambiguous form, color, light, and materials. I came to believe that this is the path to choose if one wants to contemplate the wellspring of our common psychological and emotional being.

Moreover, I believe "latent content" is ultimately the factor that determines the effectiveness of the artwork. It is not the literalness of the image, but the effective resolution of the pure form that will prove the artwork to be memorable.

I suggest that everything is primarily latent and abstract and should initially be considered so. I believe that the determining factor for lasting effectiveness for all art, including literal, popular, political, or neo-conceptual art, is its "latent content."

The intuitive subconscious can be expressed without conscious thought. However, thought must be a part of the creative process in order for intuition to take form in a painting or poem. In a haiku, the structure contains the expression of the poet's intuition. It is only a vehicle used to convey expression; the artist must make a decision regarding the structure chosen: poem, painting, performance, or something else. Ultimately, the vehicle doesn't really matter. What matters is how the literal, driving idea is embodied within the latent, aesthetic sensibility. In Barnett Newman's words: " … the spiritual content of a work of art is experienced and by its nature intangible, one cannot get any place discussing or analyzing it."[69]

INNER-AND OUTER-DIRECTED ARTISTS

There are inner-directed artists and there are outer-directed artists.

Robert Morgan[70]

Differing approaches to making art echo throughout human dichotomy: the conscious and the subconscious, the left and right brain. Artists show this dichotomy by becoming either an inner-or outer-directed artist. Inner-directed artists concern themselves with perception, phenomenology, and subconscious discovery toward expressing a personal vision. They look to art as a way to find and hopefully transcend themselves. Outer-directed artists tend toward being concerned with social discourse and popular culture, with prevailing theories and political issues. For them art is primarily a vehicle for a cause or career, notoriety, and the marketplace. Inner-directed artists are inclined to tactile expression, natural materials, intimacy and expressions that would hold the gaze of the viewer. Their art world is sensuous, aesthetically and emotionally expressive. Conversely, outer-directed artists are

FIG. 25.
Century of Busts, 1990, wood, wax, lead,
lacquer, dimensions variable.

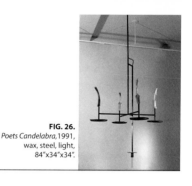

FIG. 26.
Poets Candelabra, 1991,
wax, steel, light,
84"x34"x34".

drawn to industrial production techniques, appropriation, political, popular, and theoretical content. Inner-directed artists are inclined to concern themselves with making art of high purpose and sincerity, expressing the human condition. Outer-directed artists are attuned to irony, satire, and cynicism-techniques of diversion from personal exposure. They may employ strategies of spectacle and fashion to draw an audience. The outer-directed artist is indistinguishable from the larger sphere of popular culture and commercialism. Their intentions are to become a market commodity in person and product.

The inner-directed artists are a fraternity known by artists of kind, purely through the vision and experience of their art. This fraternity doesn't necessarily exist outside the cultural-commercial art world, but it exists regardless of it.

WAX HEADS AND THE POETS CANDELABRA

Encaustic returned from Antiquity to contemporary art with the assistance of Brice Marden's monochromatic beeswax paintings during the 1960s. I took up the medium in 1990, but instead of using it as paint I stirred dry pigment in hot wax and cast it. I thought the turn of the millennium would be a good occasion to cast a hundred busts, one for each year of the twentieth century. Traditionally, busts commemorate people and by extension, their era, so I decided to commemorate time

with busts. I engraved a year on the face of each wax head and cast them tilting this way and that way in a multitude of waxy pastel colors and mounted them on memorial pedestals. A critic said they were beautiful, and they reminded him of phallus sculptures from Etruscan Antiquity. **FIG. 25, PLATES 97 AND 98.** The beauty remark reminded me of the early modernist dictum against aesthetics, which led me to make another series of elongated muddy brown wax "heads" sans traditional pedestals. These busts addressed the theme of mortality. One word was engraved on the face of each bust and all together they read: *"When Alive We're Ahead Once Dead We're . . ."* The last word of the poem was left for the viewer to think, "A Bust." The pun was intended. **PLATE 99.**

Poetry celebrates humanity. The idea of combining sculpture with poetry further inspired me to make candelabra commemorating a few of my favorite poets. Each candle was a bust, to be lit as a remembrance of the author. A box of candles with the content of the poets printed on the lid accompanied the candelabra. **FIG. 26 AND PLATE 100.**

I created the busts by melting wax in a pot on a burner and pouring it into molds on the floor. Late one night, the pot somehow ignited. Apparently, the wax had dripped on the electric hot eye and poof! I had a roaring pot of fire in a wooden building. Panic motivated me to knock the pot off its electric perch, inad-

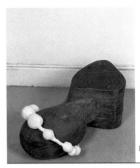

FIG. 27. *Gertrude Stein, The Mother of Modern Art,* 1991, poplar, plaster, stain, lead, 13"x16"x28".

vertently causing the melted wax to splash onto my left hand. Flames leapt across the floor nearly all the way to the turpentine, benzene, and acetone. I thought, "Oh my God, an explosion is about to happen!" The first thing I did was to smother the flaming hand. Knowing water wouldn't douse the flames on the floor, I proceeded to stomp furiously and fast across the molten wax on the floor. Luckily, I had my boots on. Once I had extinguished the flames and was relieved of my responsibility in saving the building, I examined the skin bubbling up and peeling off my hand. Now, I thought "Oh God, my hand!"

Life can seem mundane and then all of a sudden something happens to remind you that life is about continuous changes, big and small. For many of us, the inclination is to achieve a bearable routine in life, and then work to maintain it for as long as possible. Yet, life is about impermanence, chance, and change. When we want things to stay the same, we set ourselves up for disappointment. Art, like life, is about change. We should seek it. Of course, we don't look for tragedies like third-degree burns.

I bandaged my hand in paint rags, as that was all I had, and jumped on the subway to a hospital. Once there, I sat in a bit of a sweat and couldn't believe the cacophony in the middle of the night at a New York City emergency room. There were victims of car crashes, shootings, heart attacks, stabbings, and a mother-to-be in labor breathing deeply. In various poses, they stood or lay waiting to see the doctors. I stood last in line, and the carnage started making me queasy. Realizing that most of the people were worse off than me, I decided the bright red hand would heal itself and left to moan the night away.

FORMS OF ALLUSION

After I grew new skin, I decided to move away from potentially dangerous materials and turned to work in materials that were more direct. I replaced commercial production techniques with a visceral relationship with natural mediums that showed the touch of the human hand. This was also a process of emphasizing form that was suggesting associations rather than illustrating concepts. I worked in short intervals, realizing one work and then turning to create another. I thought this would encourage intuitive thinking. Carving and building seemed closer to a visceral life. Using natural materials enabled the experience of a catharsis during the making of the artwork. The sculpture continued to be associative to the figure. I intended for many of the pieces to imply a relationship with the viewer as well as a function. Together these works shared a primacy of medium and form and a secondary association to a narrative or iconography. Many of these pieces were included in the exhibition titled *Forms of Allusion* at the SoHo Center of Contemporary Art in

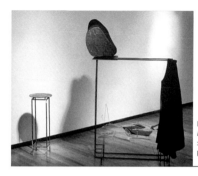

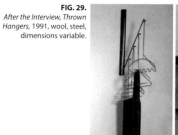

FIG. 29.
After the Interview, Thrown Hangers, 1991, wool, steel, dimensions variable.

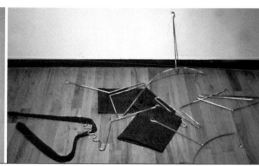

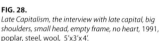

FIG. 28.
Late Capitalism, the interview with late capital, big shoulders, small head, empty frame, no heart, 1991, poplar, steel, wool, 5′x3′x4′.

1991. Each of these works was inspired by different ideas that came to me at the moment. They follow in a near chronological order. **PLATE 102.**

At the beginning of the twentieth century Gertrude Stein hosted Saturday evening salons at 27 Rue de Fleurus in Paris. These evening soirées featured the modern art collection she assembled from 1904 to 1913. Stein was patroness to many artists, including Matisse and Picasso. Her early avocation of modern art led to her becoming known as the "mother of avant-garde art." I thought by 1991 she had probably fallen off her pedestal. **FIG. 27.**

We all experience going to job interviews. Using this as a theme for art, I made a tall precarious stool for the interviewee to sit on while facing a black top-heavy sculptured figure of broad shoulders, small head, and no heart. After the interview, I imagined the interviewee going home and throwing hangers. I thought if this interviewee were someone hoping to be hired in the financial industry the artwork would be a critique of *Late Capital*. This seemed like an appropriate title at the time. **FIG. 28, 29.**

Inspired by Giacometti's 1934 sculpture *The Palace at 3 AM*, I made pieces intended to evoke absence, loneliness, and yearning for companionship. I thought to evoke the mystery of 3 am, which seemed to me to have something to do with a feeling of being disassociated from oneself and the hour. *Couples Coat Hanger at 3 AM* included two larger than life featureless carved wood busts perched at opposite ends of a long steel rod. Set high on the wall the piece awaited the hanging of the companions' coats. Copper rings commemorating vows hung from the rod. The subjects of the vows, those to hang the coats, were noted by their absence. **PLATE 101.**

It is an organic unconscious mimicry, a synchronized give and take of gestures that help create a bond between people. The wall relief *Yearning Couple at 3 AM* reflected this theme. Commas for heads represent the identical yearning couples. They stretch their vines or veins across space, reaching out to one another. **PLATE 103.**

Additional works from this period included *The Yoke of Generations*, a wall hanging work of wood and candlewicks: a generation's genes burn to a single candle, the last is yours to burn. **PLATE 106.**

The piece *The Question Is Bigger Than the Key* presents an oversized key ring leaning against the wall. It is a proposition of scale; the key to the big question is smaller than the lock. **PLATE 107.**

If painting is defined as a canvas stretched over a wood stretcher bar, Votive Stands redefines this idea. These works are a series of hand carved, three-legged wooden stands with canvas pouches stretched across the tops. Offerings of fruit lay upon the canvases. Thematically, they are akin to still life paintings of fruit. As

sculpture, they associate to evoke an undetermined primitive Earth appreciation ceremony. The viewers can eat the offerings, which shift the subject from the sculpture to ceremonial eating and a commentary on the consumption of art.
PLATES 108 THROUGH 110.

DISSOLUTION AND FORMLESSNESS

Contemporary art has finally arrived at the critical stage of its crisis, one inducing the dissolution of the component structure of art until it no longer exists in any functional capacity. Such a stage began after the formal disintegration of the art object had occurred. Furthermore the material disintegration of the art object is pretty well conceded, while the conceptual unraveling of the work of art is under way.

Jack Burnham, 1964 [71]

By the time 1990 came around, the idea of the deconstruction of art was exhausted. We can attribute the beginning of this move toward dissolution to the dadaist Tristan Tzara. Tzara made poems out of randomly thrown newspaper clippings. The poems were created by pure chance. He refused to allow the conscious self to have any role in the process. The form was appropriated and the content was devoid of meaning other than its dissolution. This was the beginning of a radical process toward dissolution and formlessness in modern and post-modern art. These "poems" were composed in the early years of the twentieth century. By the end of the century, there were many examples of art that expressed exhaustion. In 1958, Yves Klein's The Void, an exhibition of empty space at Galerie Iris Clert, was another early example of dissolution.[72]

In 1961, the Italian artist Piero Manzoni placed a large metal plinth inscribed with *The Base Of The World, Homage To Galileo* upside down in a field in Herning, Denmark. It announced that the whole world is a work of art. This ex-

ample showed the ultimate act of dissolution and its opposite, accumulation. It was around this time that the work of French artist, Arman, began introducing the concept of "accumulation" and "poubelle." Accumulations were collections of identical everyday objects in Plexiglas or glass cases. They were sliced, burned, or smashed parts of tools, watches, clocks, furniture, automobile parts, jewelry, and musical instruments in various stages of dismemberment. The "poubelles" were collections of strewn refuse. In 1960, Arman filled the Galerie Iris Clert in Paris with garbage, Le Plein as a counterpoint to Yves Klein's *The Void*.

In the late 1960s, Barry Le Va made installations of flour blown across floors. There are also Le Va's large installations involving quantities of black felt folded, cut into strips, shredded, and piled on the floor around three or four panes of shattered glass. Moreover, in 1968, Robert Morris presented an installation of thread, mirrors, asphalt, lead, aluminum, felt, copper, and steel, all randomly scattered and piled about the floor of the Leo Castelli Gallery in New York. One of my favorite examples of dissolution was Gordon Matta Clark's exhibition in 1970 at the Bykert Gallery in SoHo. In various states of growth, mold (or agar) was strung on vines in amorphous shapes and sheets throughout the room. Finally, I must not omit the Inert Gas Series created by Robert Barry in 1969. [73]

These precedents of formlessness all addressed the concept and problem of art itself. These examples of art in the process of disintegration were the end of the inquiry of art as a quest to break boundaries. At the end of a story of art in which one precedent develops from another, and the developments are a progression of reductions, the last developments possible are the degradation of form. This, therefore, is the end: anti-art and its variations, including formlessness, dissolution, and pure conceptual art. The lineage of styles culminates in anti-art and its variations. This once radical approach to art has evolved into an exercise in tired irony; artists who practice anti-art theories now try to make art that is not art but cannot,

because these theories have been incorporated, and were consumed by art long ago. These aspiring contemporary anti-artists succeed only in appearing stuck at the end of a theory. Anti-art epitomized the idea of a "breakthrough." Formlessness, dissolution, and pure conceptual art exhausted this idea. It is no longer possible. Continued expressions in this vein show only futility and a lack of historical perspective.

ANTI-ANTI-ART

My reply to Duchamp's *In Advance of a Broken Arm* (1915) was *In Advance of a Swept Room*. Both works look like they are functional objects, but this is their only similarity. By designating the utilitarian shovel as art, Duchamp rendered its functionality secondary to the idea of it being an art object. For this shovel never shoveled snow. The carved wooden broom in *In Advance of a Swept Room* is clearly not a functional broom and is never intended to sweep the floor. Thus, the broom is "posing" as anti-art. Yet, it cannot be anti-art because it is not a part of the everyday world. Although it looks as if it might be functional, it is not. Therefore, the broom is art and by its reference to Duchamp's shovel, becomes anti-anti-art. Duchamp's shovel is a utilitarian object repositioned to be an object of art. This meant he was asking the prevailing cultural discourse of his time to consider an object that was not originally made to address those aesthetic and art contextual considerations. In doing so, he rejected aesthetic and authorship conventions. Mirroring his shovel with my broom proposed the opposite. It was a rejection of the idea of anti-art for a reinstatement of aesthetic and authorship conventions. **PLATES 104 AND 105.**

NOT BEING A PHILISTINE

In short a work of art is as useless as a tool is useful. Works of art are as unique and Irreplaceable as tools are common and expendable.
George Kubler [74]

Artistic invention differs from useful invention to the degree that human sensibility differs from the rest of the universe. Artistic inventions emerge from and return to human perception, unlike useful inventions that are keyed to the physical and biological environment. Useful inventions alter mankind by altering the environment, whereas aesthetic inventions alter the sensibility of mankind. Aesthetic inventions are focused upon individual awareness. They have no explanatory purpose rather they expand the range of human perceptions by enlarging emotional discourse. Human sensibility is our only path to the universe. Useful inventions may augment these paths, but emotions function like a main valve between the universe and us. Such enlargements always remain the prerogative of artistic invention. [75]

It is not being a philistine to reject the idea of a tool as art. It is simply recognizing a theory that doesn't work. Functional art becomes non-functional when it is deemed art. The prime example is Duchamp's shovel. Duchamp presented this tool as art because it was not art. The decades of disuse of this shovel proved it not to be a tool but to be art. The irony is that through theoretical thinking this tool became art. The simple fact that this tool as art cannot be used is an example that art cannot have a function. If we accept that the "thinking of it" isn't the art, but theory existing in the greater realm of cultural discourse. Then art must be sourced to objects or physical qualities. The tool as a physical object exists apart from language and retains the possibility of a felt response to the nature of the object. This felt response is not theory; it is the object's aesthetic appeal. If art exists apart from theory and is not a tool, then its primary essence is its aesthetic appeal. If art cannot be a tool the primary concern of art is its aesthetic sensibility. By this logic all functional inventions cannot be considered art.

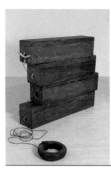

FIG. 30.
Still Lives or For All, Afterward, 1993,
wood, rope, 48"x16"x60".

FIG. 31.
Take Medicine, \Incorporated\, 1994,
wood, plaster wraps, mirror, lead,
23"x20"x18".

MY FINAL DISSOLUTION

I worked in a faux naïve style in the 1970s and early 1980s. I used simple mediums to express concepts and narratives. The primitive methods allowed for conceptual emphases. The works' handmade quality conveyed an intimate sensibility. Beginning in the mid-1980s I shifted my style towards art that was highly produced and visually abundant. In that period the emphasis on the visual took precedent over the conceptual. Complex production techniques projected a distanced, commercial sensibility. This shift in styles, from one end of a spectrum to another, was not a plan: it was a journey in search of a solution.

On coming to believe the conceptual and aesthetic inadequacy of the "display art" approach, I reconsidered working from the earlier faux naïve premise. The difference from my previous efforts in this vein was that the new pieces sprung intuitively without conceptual narrative underpinnings to drive it. I started to make things without preconceptions; ideas came later. This work was the nearest I came to embracing concepts of formlessness and dissolution. The pieces were made from simple materials constructed in a rudimentary manner. Many times, the object weren't constructed at all; they just sat upon one another. It would have been suitable if I had employed found objects. Appropriations would have contributed the concept of the absence of authorship to the work. This would add notions of random meaningless to formlessness and dissolution. But I could not bring myself to give up the idea of authorship, so I made all the objects and pretended to appropriate them. It may not have been apparent to viewers, but to my mind they became "faux found objects." This gesture was a personal commentary on those who appropriate from one who, from an ethical position, could not. Similar to *The Entourage,* this series consisted in diminutive characters made with sticks of wood combined with additional natural materials. Unlike the earlier conceptually and textually dense Entourage, these figures were a vehicle for immediate intuition, intentionally ad-hoc. The series consisted of small, stacked assemblages, each of which had its own coffin. I called the project a *Cast of Characters.* Other than that, I had no driving concepts, so I simply named the characters after friends in the neighborhood.

While I was making the characters I began to think about all the precedents of dissolution, starting with the dadaists of 1910s through the 1970s and 1980s. I realized this theme of exhaustion had been thoroughly mined. The goal of devalued art, formlessness, and dissolution had been reached long before me. The idea you could make art from detritus was an idea that had died. It seemed apparent that the next logical step from this position was to not make art at all. The coffins proved to be functionally useful as my "characters" stood for their day and were each embalmed. **FIG. 30, PLATES 111 THROUGH 123.**

OUR LAST SLEEP WE FLY

The next project, an installation titled *Our Last Sleep We Fly* was also concerned with mortality. Unlike the *Cast of Characters,* the work was not stylistically distressed. It seemed to me that trying to be degraded and inept was antithetical to trying to be inspired. Dissolution was depressing. It was also stylistically exaggerated, as was its stylistic exaggerated opposite, "display art." In *Our Last Sleep We Fly*, the form did no more than what was necessary to express the content. The artwork was substantial and well made, but the form did not call attention to itself. Here, style became an unassuming vehicle delivering the content.

In the 1980s New York seemed to be the epicenter of the AIDS epidemic. Everyone seemed to have friends and loved ones who suffered. The tragedy of dying from AIDS was the inspiration for this installation. *Last Toast, Be Exposed, Have Solace, Bid Farewell, Take Medicine, Throw Lamps, Last Lay, Tossed Cover, For All, Afterward, Below, and Beyond* were the titles of each work in the show. Also, I wrote in the catalogue, "On that death day, the glance is diverted, the sequence carries one along: light your candle, tip your wine, hang up your clothes, then to bed, the cover, the medicine, the thrown lamp, pine boxes, and thereafter. We all will do it but once, exposed and alone." The narrative was communicated through various media, some of which referred to traditional definitions of painting and sculpture and others to objects used in everyday life. Similar to a piece of furniture, each object in the installation implied an absent figure. I included in the installations the coffins of the previous project, with their "characters" secretly inside.

In the text for the catalogue, the art critic Nancy Princenthal wrote, "In the sculpture called *Medicine,* the word printed backward on the wall, and restored to sense by the mirror on the cabinet's door, is 'incorporeal.' An immaterial, illusory image of a verbal sign, it is its own representation. It is also an answer to the question, 'What does medicine shut itself against?' But it is a reply delivered from above, describing transcendence over the body, rather than simple absence. Traveling the same distance with your feet on the ground, you reach the less exalted physical truth of death. In this installation, Holl gamely sets out in both directions at once, a drink *(Last Toast)* in one hand and a blaze of candles *(Bid Farewell)* in the other. Looked at one way, these painted and carved props are artificial—fakes—and won't do him any good. Looked at another, they're art, one of the only shots at immortality we've got. Holl's medicine chest hangs askew, and its contents, pretty white plaster bandages all in a row, are soothing, but not universally availing. If they fail, a stack of four coffins is at hand. Nobly carpentered but stingy in their proportions, these short and narrow boxes are final resting places for bodies already withered, dematerialized. Which is just as well, since the coffins are built for portability, fitted with small wooden loops through which is threaded a single string, with a rudimentary handle. They could be dragged through dusty streets in a procession of neo-medieval penitents. Or tightly warehoused, with less ceremony, but to the modern eye more despair. The coffins, *For All, Afterward, were originally called Still Lives,* because Holl likes wordplay, and isn't shy about the big questions . . ."

FIG. 30 AND 31, PLATES 124 THROUGH 129.

TODAY'S BREAKTHROUGH IS CODE

The argument has been made that art advanced through technological breakthroughs, i.e. the invention of oil paint, the discovery of perspective, etc. However, these "inventions" served art as a polemical inquiry, not to advance a tool. From the view of contemporary technological inventions, digital and biological technologies are where the "breakthroughs" that serve art occur today. Certainly the fact that most of these digital inventions are tools does not deny their significant creative contributions. That said, there are also many examples of digital tools created purely for polemical or sense reasons. All of these examples, whether they are used for

bioengineering or communication or interactivity, or whether they are used to create light, sound, or image, etc., are sourced in code. I believe the most remarkable breakthrough is the ability to redesign life by manipulating DNA. Undeniably, this science is the endgame for artists proposing the idea that life is art. These digital or biological breakthroughs do not occur through the mere manipulation of imagery or sequence, although these have pre-engineering precedents, but in the realm of code. I believe this medium of digital or biological code to be the last arena of inquiry to follow the modernist narrative of breaking boundaries, presupposing new form before becoming through repetition, a style. All other artistic expressions will occur within a style predetermined by precedent.

THE LONG MOMENT

> *Is it our thought that determines the a priori nature of the world? Or is it the world that determines how we must think it? The answer, I believe, is "neither, and both."*
>
> **Immanuel Kant** [76]

Is it that time is different for each of us? Time and its limits are what motivate questions of mortality and permanence. Time is at the root of science and religion, and also a fundamental reason for art. We inhabit time, space, matter, and causality, and we experience them working together seamlessly. Imagine a fracture occurs in everyone's ability to remember. If that happened, humankind would return to animal instincts, unable to understand the workings of the twenty-first century. Causality allows us to make sense of our perspective on the world. We need time, space, matter, and causality in order to exist. By inference, they are not divisible, but instead are part of a whole. We are self-aware sparks, lights destined to burn out. We come into this conjunction of time, space, matter, and causality to experience and leave. However, that coming and going suggests that there is a place we come from and a place where we will go. Our awareness suggests that there is something other than our awareness.

Imagine there is a mirror universe where time, space, matter, and causality function as they do in our universe. Everything we are and experience would exist as an opposite on the other side. When we are in agony, our duplicate is in ecstasy. There are dimensions we can only imagine. In the 1970s, physicists came up with a theory of everything. They called it "Supersymmetry," and it implied that every known particle (electrons, etc.) had a mirror matter called "sparticles." This is a dark matter that cannot be seen but holds the universe together through gravity.[77] Apparently, we cannot exist without what is on the other side, and apparently there are many other sides. "String Theory" postulates there are ten or more space-time dimensions, and we experience only four.

Imagine a sculpture was to express what exists on the other side of our awareness. It might look like this: two parallel steel rods six inches in diameter and six feet long. They would look like pencils, round with a cone point on one end. They hang at eye level, horizontally in space at a right angle to the wall. The "pencil" point would touch the vertical wall. One six-foot rod would rest with its energetic point touching the wall. The other rod would be missing the pencil point half. It would be suspended in space, not touching the wall. The sculpture would be called *Two Identical Rods, Half of One on the Other Side.*

Can we know the instant between the ticks of a watch? Or is it actually a void, an interval, an infinitesimally small but ultimately real rupture between past and future? Is it an immeasurable pause when nothing happens? How can it be real when it cannot be held or identified? Are we not living an instant in the past, receiving sensation after it has occurred?

What if time did not change, did not progress in a forward direction? What if it were the way we experience time that made it seem to go forward? In

this version of time everything that ever happened is happening at the same time eternally. Time would be like a vast frozen crystal where all past and future events exist statically as a long moment. By our experience we would string them together as we pass through them.

The sculpture *Passing Times* presented time as overlapping rotating discs. Each disc represented a separate moment. Hovering upon these moments was a comma; both a head and a pause encased in a glittering container from which light emanated. The light represented the spark of awareness. Compositionally each disc appeared to move from right to left, but they were static, as if frozen in time.

PLATES 91 AND 92.

FREE PLAY

> *Aesthetic judgment seems to be in conflict with itself: it cannot be at the same time aesthetic (an expression of subjective experience) and also a judgment (claiming universal assent).*
>
> **Immanuel Kant [78]**

Kant thought imagination could be "freed from" concepts (that is, from the rules of understanding). It is this "free play" of the imagination that characterizes aesthetic judgment. In the free play of imagination, concepts are indeterminate. An example would be an abstract picture without assigned meanings. The viewer would only be able to experience that indeterminate idea. I believe this free play before assigning meaning allows for an indeterminate felt response. Kant felt that instilling experience with concepts is the work of the imagination. It is through a "synthesis" of experience and concept that turns the abstraction into an imagined representation of a face.[79] Kant distinguishes "free play" from "dependent" beauty (his term). "Dependent" would mean a judgment of aesthetic sensibility could not be made until the object in contemplation is brought under concepts. He felt that the "dependent"

aesthetic judgment is not as pure as the "free" aesthetic judgment and would become pure only for the person who had no concept of the meaning or function of what he saw. He thought the purest examples (of beauty) are therefore "free." [80] Thus, we can understand that contextualization of art, its very inclusion in the "cultural discourse," undermines and compromises an individual's ability to experience the purity of a genuinely felt response and to have an aesthetic impression. Art made with the intention to address the cultural discourse or the context of art diminishes the idea that phenomenological experience is the primary wellspring of creative expression.

SENSIBILITY AND UNDERSTANDING

There are two sources from which our knowledge is drawn: sensibility and understanding. The first is a faculty of intuition; it includes all the sensory states. The second is a faculty of concept. Since concepts have to be applied to judgments, this faculty, unlike sensibility, is active. There are two faculties here, two opposites, yet they can supply objectively valid judgments of things only in conjunction with each other. A judgment requires, then, the joint operation of sensibility and understanding. A mind without concepts would have no capacity to think; equally, a mind armed with concepts, but with no sensory data to which they could be applied, would have nothing to think about. [81] Kant called for a "synthesis" of concept and intuition, and only through this synthesis is true experience generated. Apparently for Kant, true experience requires intuition with connections to concepts. "I do not lay hold of my experiences and then subject them to synthesis. For the very act of 'laying hold' presupposes that this synthesis has occurred." [82]

Can we admire the majesty of a tree without the concept of it? I believe so. I think intuition can precede concept in a primary state of awareness and perception. By concepts we remake things to be communally understood, regardless of

what they may be otherwise. This is what culture does: it provides concepts to promote consensus. Culture essentially opposes what, after years of exploration, I came to think art should do: transpose concept and intuition.

BOLTZMANN'S BRAINS

Imagine us as some momentary fluctuation in a field of matter and energy in space. Imagine we are floating "brains" rather than people with bodies, with pasts, presents, and futures. In 1987, I had premonitions of these floating brains. I was thinking about intuition, wondering how it springs forth, seemingly out of nowhere. It seems to arrive in the mind from outside the body. The Figments of Imagination series of wall reliefs expressed this idea. I etched outlines of brains in glass, lit them from within, and suspended them before a representation of warped space.

PLATES 93 THROUGH 96.

Twenty years later I read about a theory, currently being debated, that these sculptures illustrated. The theory, known as the Boltzmann Brain Problem, was named after the nineteenth-century Austrian physicist Ludwig Boltzmann,[83] it stems from a string of logical conclusions that derive from another old and deep question, namely why time seems to go in only one direction. Dr. Leonard Susskind, of Stanford University, who helped set off the debate about the Boltzmann Brain Problem, points out that this question is "part of a much bigger set of questions about how to think about probabilities in an infinite universe in which everything that can occur, does occur, infinitely many times." [84]

Dennis Overbye, a deputy science editor for *The New York Times*, said, "The basic problem for cosmologists is that across the eons of time, the standard theories suggest the universe can recur over and over again in an endless cycle of big bangs. Nature tends to do what is easiest, from the standpoint of energy and probability. It's hard for nature to make a whole universe. It's much easier to make fragments of one, like planets, or people or even—in the most troubling example— a naked brain floating in space. These fragments—in particular the brains—would appear far more frequently than real, full-fledged universes, or than us." [85]

On reading about this theory, I was taken with how related ideas occur in different places and time without having any apparent connection with each other. It is as if a particular idea exists in itself outside in space and for whatever reason chooses to pop into one or many minds concurrently or at a different time and place. Moreover, coming to know about the Boltzmann Brain Problem added credibility to the idea of disembodied perception, singular floating awareness as a subject for art.

MY BRAIN

The perception of time began not with the universe coming into existence, the "big bang," but with the advent of the single-celled organism, the emergence of life. A new era of information processing was born at the molecular level. Through the manipulation of atoms and molecules into DNA and RNA sequences, information could be entered, coded, and stored for future use. By this life of the cell began the perception of the arrow of time. Cells could retain information and add to this more information for future use. Hence ourselves.

Our human genetic code is constructed with the exact same four nucleotides (complex molecules) as every other form of life on the planet. At the level of DNA, we are related to the birds, reptiles, amphibians as well as plant life. Our ability to process data about the external world begins at the level of sensory perception. Our sensory receptors are designed to detect information at the energy level. The world we live in, everything we sense through experience, is composed of spinning and vibrating atomic particles. The world is a turbulent sea of electromagnetic fields. What we make of this sea of energy is the result of our sense receptors. Our visual field, our view of the world, and everything we gaze upon, is actually

divided into billions of tiny spots. Each spot is filled with atoms and molecules that vibrate. The retinal cells detect atoms vibrating at different frequencies and emitting different wavelengths of energy. This information is then coded into colors, edges, orientations, depth, and motion in the brain. Our ability to hear like our ability to see also depends upon our detection of energy traveling at different wavelengths. The energy wavelengths of sound vibrate in our eardrum and the reception of energy also enables smell, taste, and touch.[86]

Each of us is comprised of trillions upon trillions of vibrating particles. We are embodied in fluid-filled skins in a fluid world where everything exists in motion. Different entities are composed of different densities of molecules, but ultimately every dot is made up of electrons, protons, and neutrons performing a delicate dance. Every dot, every person, and every bit of space in between is atomic matter and energy.[87] Our sense receptors receive this energy and send it to the most primordial part of our brain, sometimes referred to as the "reptilian brain." This part of the brain assigns emotion to this energy. By the time a message reaches our cerebral cortex for higher thinking, we have already a "feeling" to how we view that stimulation.[88] From a biological perspective this means we are feeling creatures who think. Not thinking creatures who feel. It is interesting to note how prescient Van Gogh and other impressionists were with their dabs of paint and points of color in portraying the biological facts of perception long before science did the research. The impressionists showed what science later explained. This is another example of how related ideas occur in different places and times. These artists experienced and expressed the feeling of the perceptual stimuli without scientific analysis. Their art was their analysis whereas empirical science worked conceptually in order to answer the questions of perception. Scientific analysis of perceptual stimuli does not require experience from a felt point of view yet both scientist and artist across time addressed understanding the same phenomena.

The brain is divided into two hemispheres: the right hemisphere and left hemisphere. They are joined by the *corpus callosum*. This part of the brain connects the two hemispheres, allowing them to work together to affect seamless perception of the world. The brain appears to work as a whole, but in reality, the right mind and left mind cognate specifically. To the right mind, no time exists other than the present moment, and each moment is vibrant with sensation. This is where our perception and experience of connection with something that is greater than us takes place. To the right mind, the moment of now is timeless and abundant. The right mind is free to think intuitively, to be creative. The right mind enables the capacity for spirituality, for a phenomenologically felt response to the world. In contrast, the left mind processes information differently. It takes the spontaneous moments experienced by the right mind and orders them sequentially. It compares details of one moment to another in a linear and methodical configuration. This allows for the conception of time: our past, present, and future. The left mind is for deductive reasoning, categorization, details, language, and numbers. It weaves stories, gives explanations.[89]

In order to take part in society, all of us access both sides of our brain, but by inclination most process the world primarily from one or the other hemisphere. Considering the culture of the art world from these opposite inclinations is to see a dichotomy. Those of us who experience the world primarily from our left mind and rely on the cerebral cortex will stress analysis and interpretation. These people interpret the world through language and theory. Those who see the world primarily from their right mind and allow for feelings to occur unmediated by the cerebral cortex will feel the primacy of emotion and viscerally experience perceptual stimuli. These people interpret the world through form and unmediated emotion.

By the necessity of discourse, the culture of the art world is dominated by language and theory. Artwork from this left-brain approach is literal, iconographically

driven, conceptually strategic, and contextually self-referential. This dominant inclination suppresses art in contemporary culture that emphasizes form and emotion and by extension what I believe to be the primary wellspring of art: intuition and visceral perception.

SENSIBILITY IS THE BETTER WORD

If one participates in this culture, one must make judgments and render a feeling in concepts and words. If one looks to experience the "right mind," all that is felt will be emphasized over what is thought. The emphasis on intuition and feeling is to stress latent content over the literal content. This, in turn, brings aesthetic considerations to the fore, as aesthetic considerations express felt responses first. According to eighteenth-century concepts, the term "aesthetic" is constrained by ideas of the beautiful and the sublime. A better word for "aesthetic" is "sensibility." Sensibility can encompass the entire spectrum from ugly to beautiful and from banal to meaningful. Judging how convincingly a particular sensibility is expressed allows for a determination of quality.

The issue would not be whether the sensibility is beautiful or ugly, or the style of the vehicle enabling the expression. An unconvincing sensibility is mired in indecision. I suggest that in the clarity of what one might consider truly ugly, the redeeming values of the beautiful can be discerned. My notion of "sensibility" isn't derived from the literal meaning, but rather it is found in the latent meaning, which is the expression of the artist's meditations of felt experience through his particular sensibility. Asserting literal meanings impedes sense appreciation.

An example would be to experience a catharsis while listening to music without knowing anything about structure, technique, or literal meaning. This shows how important it is to retain an appreciation of effective sensory expression in the critical discourse of the arts. I believe sense expression is, in itself, enough: an artwork may have, but needs, no other redeeming value.

IN THE END

This above all: to thine own self be true, / And it must follow, as the night the day, / Thou cans't not be false to any man . . .

Act I, Scene III of Shakespeare's *Hamlet*

My journey as an artist began and returned to the search to find out how to be true to the self. Coming to know oneself is the fundamental opportunity afforded us by our time on Earth. The quest for answers to "life's mysteries" is a spiritual journey. All other occupations add to or distract from this reflection. In the name of art, I addressed art theory, art history, the art context, art as the subject, the viewer as art, the artist as art, neo-conceptual art, narrative art, installation art, pop art, faux commodity art, anti-art, dissolution art, political art, painting as art, and sculpture as art. At times during this experience, I came to suspect that I was engineering effects for an audience. I was approaching art with, at best, the mind of a designer, and at worst, with the intentions of a marketer. I realized I was making cultural statements without personal investment. In order to be authentic, I decided that personal investment was paramount. Fashion, popular culture, politics, art theory, art about art, and art about the cultural discourse all mask personal investment. I spent the years between 1974 and 1994 thinking about these issues. Finally, I realized I had to stop and step back from making art with intentions of addressing cultural and theoretical issues. I decided that foregoing engagement in the cultural discourse to be the last radical gesture an artist could make. Personal investment is putting oneself into artwork without reservation. It is analogous to the expression of the music of one's soul. Experiencing music is to feel a vibration. Seeing color and form is to feel vibration. These vibrations are similar to the spark that is one's life. To feel one's unique vibration and express it through one's aesthetic sensibility is what art is for me. From this point of view I critique from a hierarchy of relevance, first from the point of view of the aesthetic sensibility and then the ethical, the theoretical, and

the historical, followed by the political, the commercial, and lastly, the anti-artists and the "nasties."

ESSENTIALISM

Most of the cells in our body die and are replaced every few weeks or months. Only the primary cells of our nervous system stay the same, since the neurons in our brain do not multiply after we are born. It is the stability of these primary cells that for the most part allows us to feel that we are the same people, from birth to death. Everything else changes. [90]

One recent summer morning I woke up by a pool. It was a wonderful sunny morning. Nearby, the ocean waves crested upon the beach. I awoke upon a thought of an essence, something true and unchanging, I was lamenting years of doubt. Over the decades, I followed one path then another looking for a quintessential definition of art. Each journey ended in doubt. Lying there I thought, "art is not essentialism." Plato was an essentialist. He believed in ideal forms of which every object is just a poor copy. I thought if there is no ideal, no center to find in art, it is all a process, and the thing called art is what is left of what happens along the way. This essay has been the story of those attempts and my realization that art is the onion that has no core. Everything is impermanent. In all its variety, everything made reflects a passing moment. This essay is a eulogy to letting go of all the anxiety spent searching for quintessential form.

LINE AND DOT

Time is a line and it has directions. We are a dot, a spot on that line; we are coming from and going to. Life and art are dots on a timeline. If we disregard all the storylines of life found in art, then all of the forms in art are fundamentally lines and dots. With the addition of space, they are places and directions.

The linguistic professor, Dr. Malotki, studies "phosphenes," a kind of test pattern of the visual system. He says: "Phosphenes show the same fifteen abstract geometric constants that appear globally in art created as early as 30,000 years ago. They are grids, zigzags, and dots." [91] Essentially, before stories there were dots and lines. Turn a line on its end and it's a dot.

I HAD A DREAM

I had a dream I was inside a square and I saw two things—I couldn't tell what they were, maybe dots or rocks. The young girl across the one-lane road said "mushrooms." There was no horizon line, so I couldn't tell the scale—maybe they were mountains or pebbles. I was above them; there was light and space. I saw shadows. One of the dots said to the other: "Can you feel it?" The other replied: "Is that all there is?"

PLATES

Palette

PLATES O1 THROUGH O4. *Preacher's Principles,* 1977-1978, paper, plaster, wood, hat, photo performances, dimensions variable.

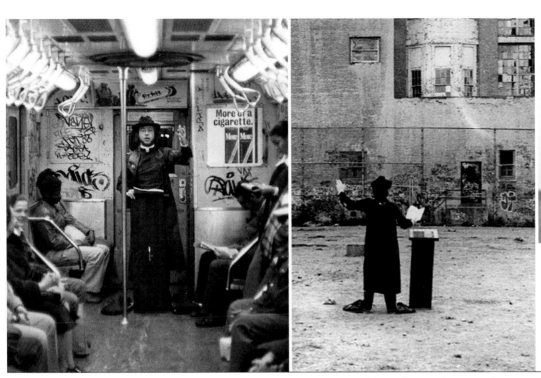

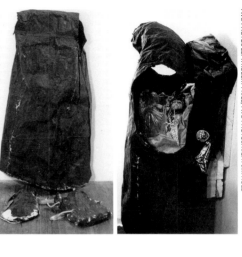

PLATES 05 AND 06. *Preacher's Principles*, 1977-1978, paper, plaster, wood, hat, subway and street performance, dimensions variable.

PLATES 07 AND 08. *Preacher's Principles and Man on Earth Shoes,* 1977, paper, plaster, wood, figurines, coat, 36"x24"x26".

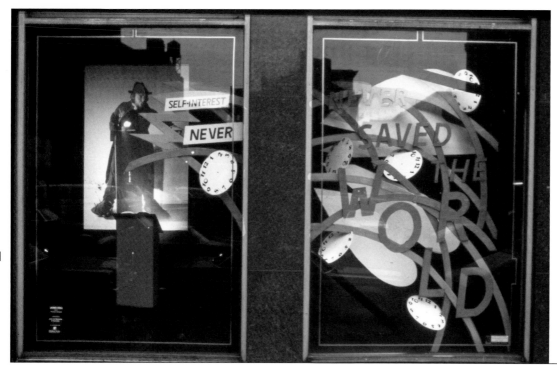

PLATE 09. *Self Interest Never, Never, Saved the World,* 1980, lights, photo, wood, foam core, clock faces, 144"x96".

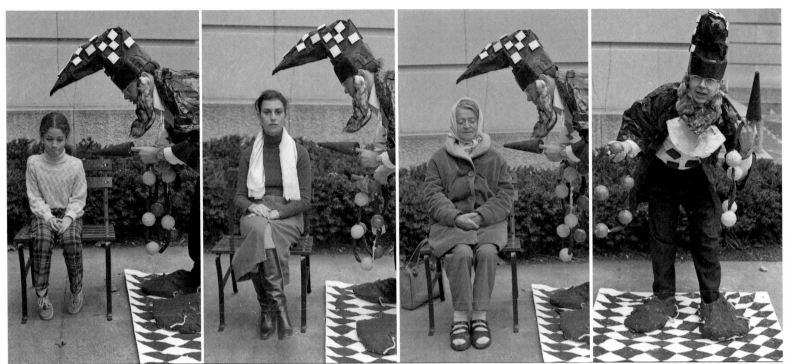

PLATE 10. *The Harlequin Posing as Old Man Time,* 1979, paper, plaster, cotton, people, dimensions variable.

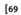

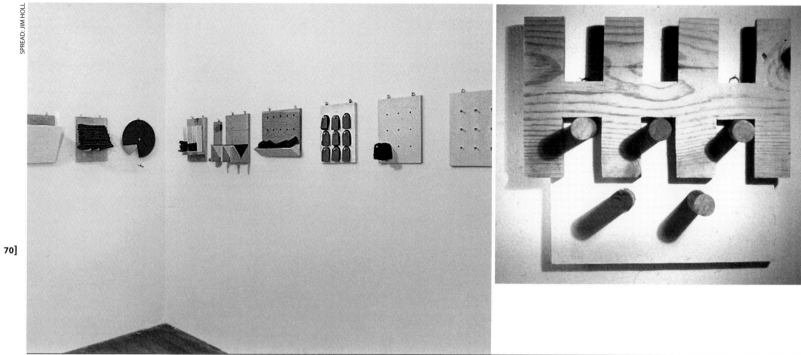

PLATE 11. *Peg and Slot Games*, 1977, installation view, paper, oil paint, wood, dimensions variable.

PLATE 12. *Peg and Slot Games, Try Me One,* 1977, wood, gesso, 14"x11"x3".

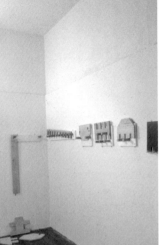

PLATE 13. *Peg and Slot Games, Try Me Two,* 1977, wood, gesso, 38"x8"x3". **PLATE 14.** *Peg and Slot Games,* 1977, installation views, paper, oil paint, wood, dimensions variable. **PLATE 15.** *How to Construct a Painting,* 1977, installation view, oil paint, wood, dimensions variable.

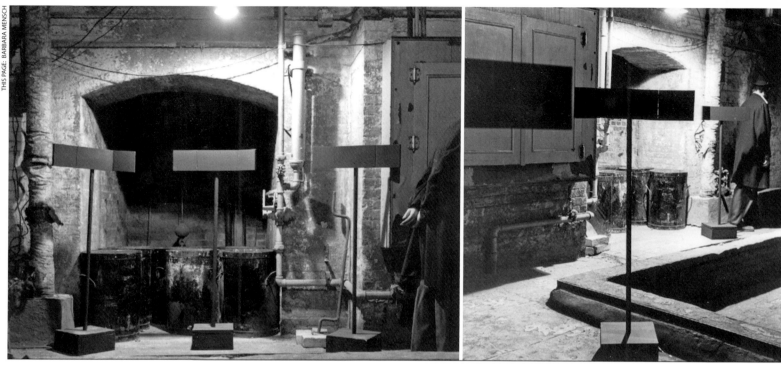

PLATES 16 AND 17. *When Creatures Crawled From the Bowels of the Earth,* 1978, artist, people, wood, steel, lights, water, dimensions variable.

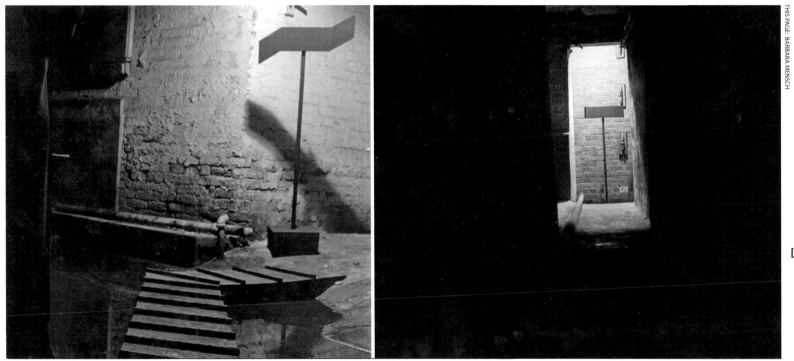
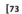

PLATES 18 AND 19. *When Creatures Crawled From the Bowels of the Earth,* 1978, artist, people, wood, steel, lights, water, dimensions variable.

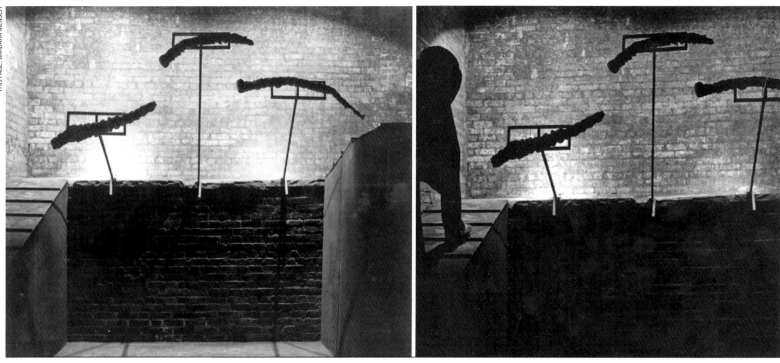

74]

PLATES 20 AND 21. *When Creatures Crawled From the Bowels of the Earth,* 1978, artist, people, wood, steel, lights, water, dimensions variable.

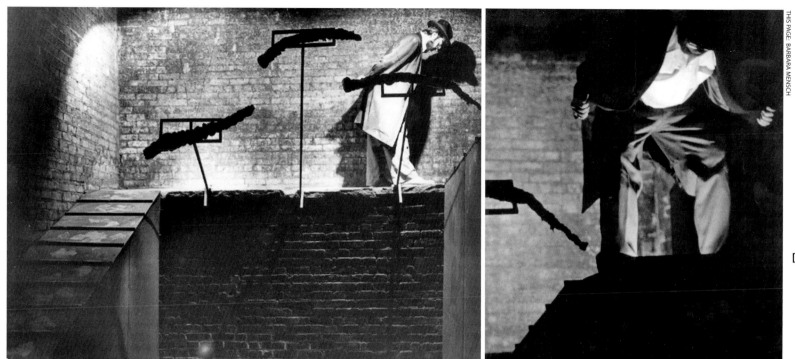

PLATES 22 AND 23. *When Creatures Crawled From the Bowels of the Earth,* 1978, artist, people, wood, steel, lights, water, dimensions variable.

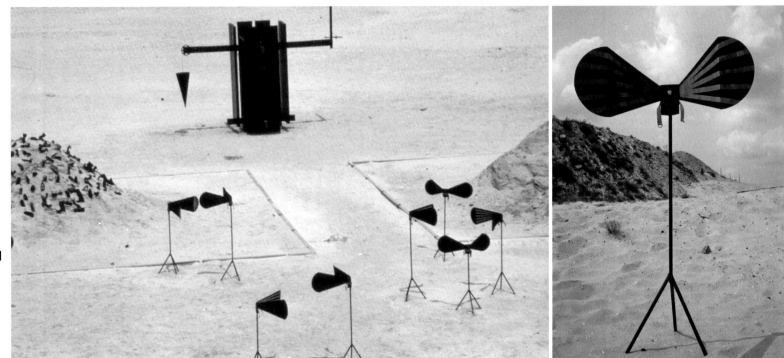

PLATE 24. *Civic Plots, Art on The Beach,* 1983, sand, steel, wood, tape recorders, shoes, money, people, dimensions variable.

PLATE 25. *Civic Plots, Art on The Beach*, *Megaphone,* 1983, steel, wood, one of many, dimensions variable.

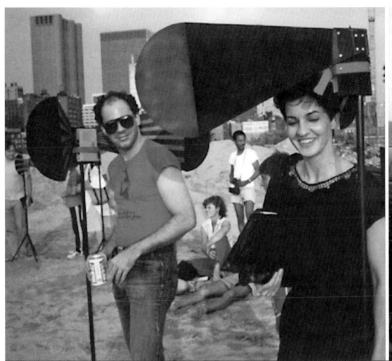

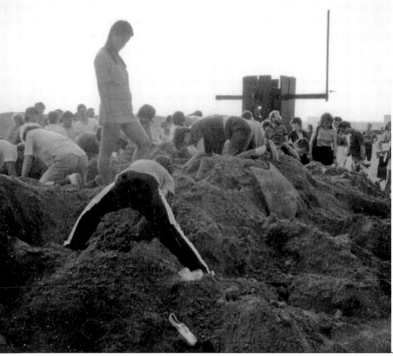

PLATE 26. *Civic Plots, Art on The Beach,* 1983, people listening to talking megaphones, steel, tape recorders, dimensions variable.

PLATE 27. *Civic Plots, Art on The Beach*, 1983, people digging for golden slippers, dimensions variable.

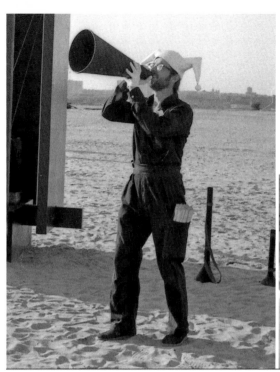

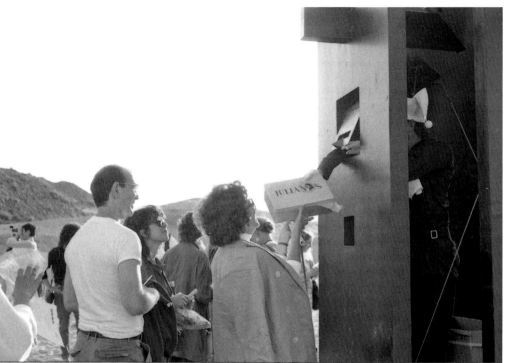

PLATE 28. *Civic Plots, Art on The Beach, the Harlequin*, 1983, artist and megaphone, dimensions variable.

PLATE 29. *Civic Plots, Art on The Beach, Harlequin giving shoes from the Sentinel Booth*, 1983, artist, wood, steel, people and shoes, dimensions variable.

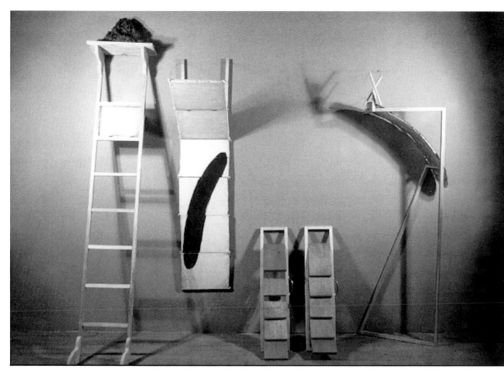

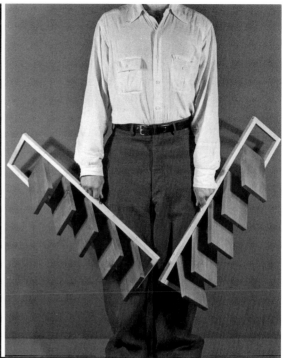

PLATE 30. *The Entourage, The Mate and The Deciding Man,* 1978, wood, canvas, oil paint, dimensions variable.

PLATE 31. *The Entourage, The Deciding Man Could Not Decide, Which Accoutrement,* 1978, wood, artist, stain, dimensions variable.

THE ENTOURAGE

The Guide accepted the responsibility: he said he knew the way to find a new future. Together The Guide, The Deciding Man, and his Mate embarked upon a journey. Late in the journey, The Guide realized he was lost. The landscape was no longer what it used to be. Throughout their travels, The Deciding Man's Mate talked about the proper place things should be put. The Mate spent all her time moving and adjusting their things to where she felt they should be set. The men thought this activity foolish but tolerated her nonetheless. Meanwhile, The Guide was lost in the landscape: he felt he had led his companions astray. Yet he tried to hide his doubt from his followers, for he feared losing their confidence. Finally, he thought he might decide to turn the entourage back to recover what they had left behind. But even this direction he could not be sure of, for alas the poor man had lost his aim. The Guide began to worry, he tried and tried to hide his anxiety. Fortunately for his leadership, his companions did not notice: they were so taken up with their own concerns. The Mate felt she should explain where to put their things. She called both of them to come and listen to her lecture in past tense. "Put, Put, Put, Do, Did, Dent." Her husband The Deciding Man, said he was too busy with his own important decision. But The Guide came to listen and he noticed that The Mate's breasts dented her blouse. During The Mate's lecture, the deciding man paced back and forth. All he could think of was his own important decision, "Which accoutrement?" Yet he wouldn't confide in The Mate for he thought she was a fool, nor would he ask advice from The Guide, for he hoped to hide his indecision. He found his relief only on leaving his mark upon his Mate. As for The Mate, when she saw him coming, she covered herself and stooped so she might seem to worry as much as he. This was her compromise, her commitment. This was how she bore his brand. His mind was tangled, his thoughts confused: no matter how he tried, he could not decide. "When to put, Sunday Morning 1917, Where to put, Bismarck, Arizona 1937."

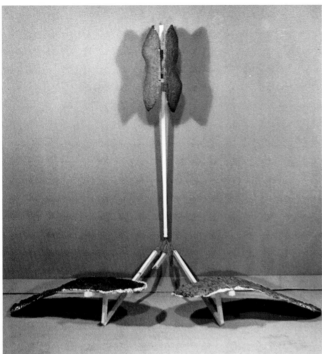

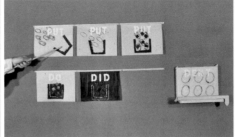

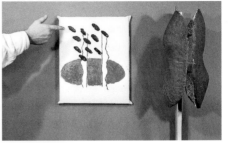

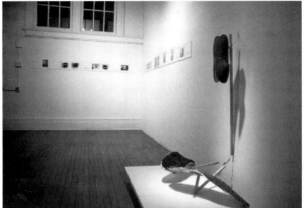

PLATE 32. *The Entourage, The Guide,* 1978, wood, paper, tin, oil paint, 40"x36"x24".

PLATE 33. *The Mate gave a Lecture in Past Tense; Put, Put, Put, Do, Did, Dent, is How to Make a Painting,* 1978, wood, paper, oil paint, artist, dimensions variable.

PLATE 34 . *The Entourage, The Guide,* 1978, installation view, wood, paper, tin, oil paint, dimensions variable.

.

PLATE 35. *The Entourage, The Guide was Lost, the Landscape Wasn't What it Once Wa*s, 1978, wood, canvas, oil paint, artist, dimensions variable.

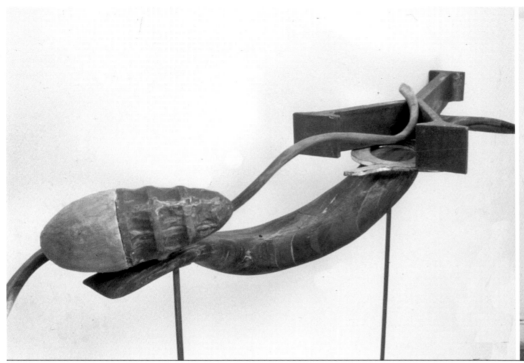

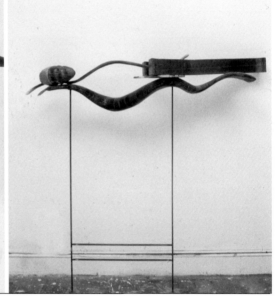

PLATE 36. *Two Whys and a Q,* 1990, wood, steel, wax, lead, silver leaf, stain, installation detail, 56"x50"x20".

PLATE 37. *Two Whys and a Q,* 1990, wood, steel, wax, lead, silver leaf, stain, 56"x50"x20".

82]

PLATE 38. *The Scientist and the Sea,* 1979, photostat, 20"x16".

PLATE 39. *The Scientist and the Sea,* detail, photostat,12"x16".

PLATE 40. *The Scientist and the Sea,* photostat, dimensions 12"x16".

The Scientist and The Sea — page 11

The Scientist and The Sea — page 17

PLATE 41. *The Scientist and the Sea, Coloring Book,* 1979, photostat, 12"x16". **PLATE 42.** *The Scientist and the Sea, Coloring Book,* 1979, photostat, 12"x16". **PLATE 43.** *The Scientist and the Sea, Coloring Book,* 1979, photostat, 12"x16".

PLATE 44. *The Scientist and the Sea,* 1979, installation view, wood, photostats, acrylic, fish, bread, glass, 16"x6"x96".

 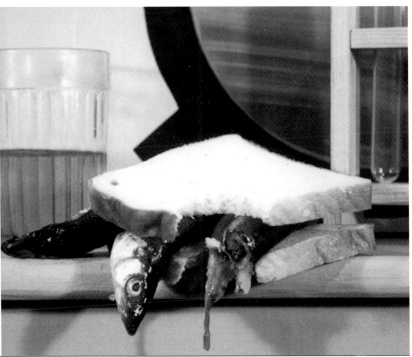

PLATE 45. *The Scientist and the Sea*, 1979, installation view, wood, photostats, acrylic, fish, bread, beer, glass, 16"x6"x96".

PLATE 46. *The Scientist and the Sea*, 1979, installation detail, wood, photostats, acrylic, fish, bread, glass, 16"x 6"x96".

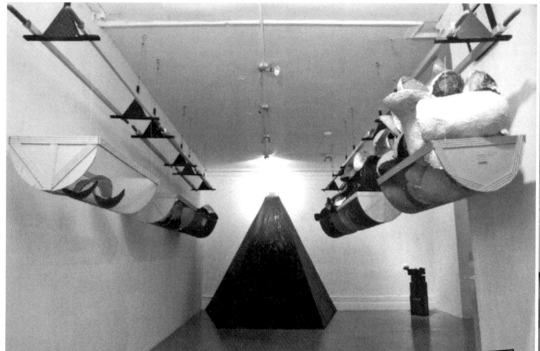

PLATE 47. *Wake Up It's Time To Go To Work,* 1980, installation view, tar, wood, steel, paper, tin, dimensions variable.

PLATE 48. *Wake Up It's Time To Go To Work,* 1980, installation view, wood, steel, paper, tin, lights, dimensions variable.

PLATE 49. *Wake Up It's Time To Go To Work,* 1980, photostat, 10"x16".

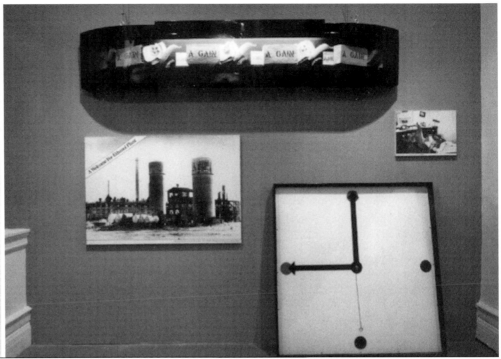

PLATE 50. *Wake Up It's Time To Go To Work,* 1980, installation view, wood, steel, paper, tin, dimensions variable.

PLATE 51. *Wake Up It's Time To Go To Work,* 1980, installation view, photos, wood, steel, paper, lights, rubber, dimensions variable.

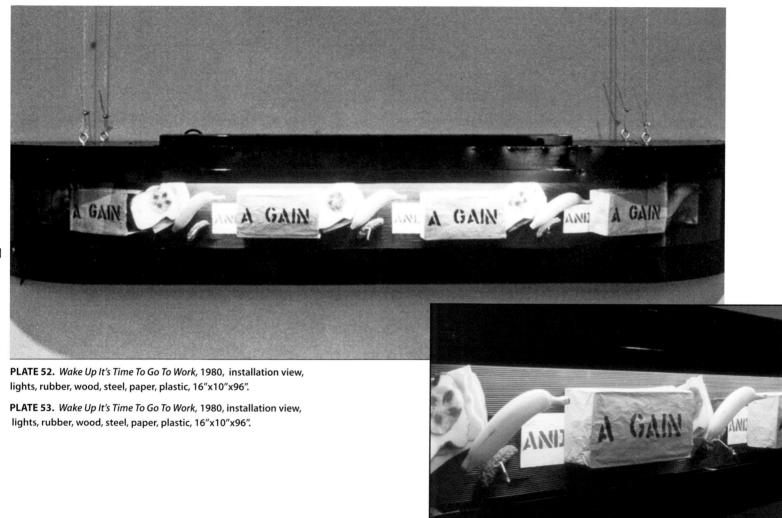

PLATE 52. *Wake Up It's Time To Go To Work,* 1980, installation view, lights, rubber, wood, steel, paper, plastic, 16"x10"x96".

PLATE 53. *Wake Up It's Time To Go To Work,* 1980, installation view, lights, rubber, wood, steel, paper, plastic, 16"x10"x96".

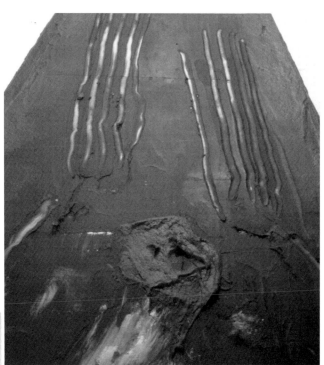

PLATE 54. *Sisyphus and the Tar Mountain,* 1980, installation view, wood, tar, 16"x10"x96".

PLATE 55. *Sisyphus and the Tar Mountain*, 1980, detail, tar, wood, steel, 16"x10"x96".

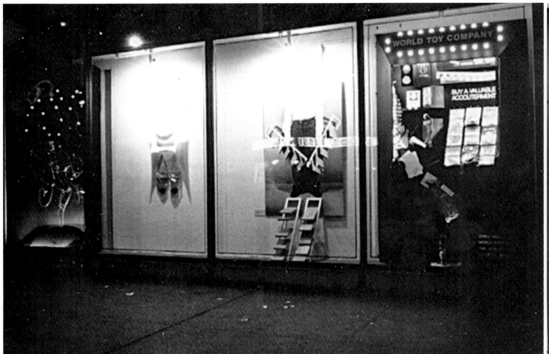 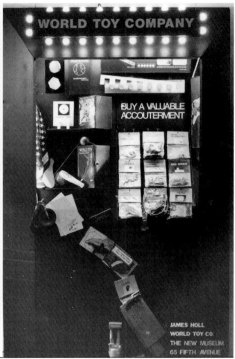

PLATE 56. *World Toy Company,* wood, paper, plastic, lights, cloth, steel, oil paint, rubber, 100"x240"x36".

PLATE 57. *World Toy Company,* wood, paper, plastic, lights, cloth, steel, oil paint, rubber, 100"x240"x36".

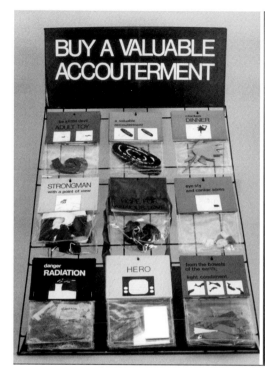

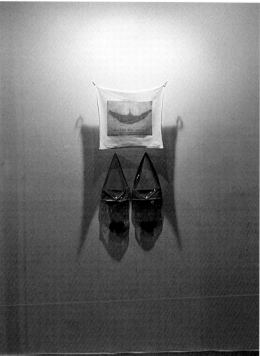

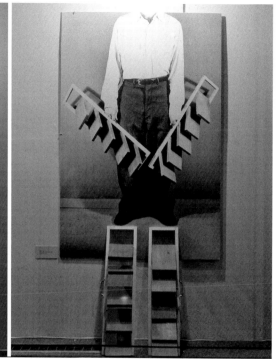

PLATE 58. *Buy a Valuable Accouterment,* display rack, nine sets of "World Toy" packages, 1981, mixed media, 30"x20"x18".

PLATE 59. *The Deciding Woman Could not Decide, Which Accoutrement,* 1981, T-shirt cloth with photo of two balloons, two identical purses holding coal to "light my fire," 100"x60"x36".

PLATE 60. *The Deciding Man Could not Decide, Which Accoutrement,* 1981, photo, wood, 100"x60"x36".

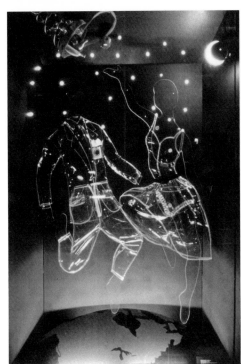

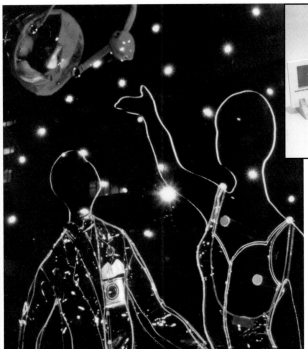

PLATE 61. *The Origin of Want Dancers,* 1981, transparent figures leaping for want of the cornucopia, lights, acrylic, plastic, wood, oil paint, 100"x60"x36".

PLATE 62. *The The Origin of Want Dancers,*1981, detail, lights, acrylic, plastic, wood, oil paint.

PLATE 63. Left to right: *Three Box Toys: Vanishing Point,* a moveable hole establishing the position of the point. *World Toy, How Men Think, Pow,* paddle and ball, bat and world. *Corporate Power Presents Frustration, You Play Their Game,* the blocks don't fit into the holes, 1981, wood, paper, photostats, dimensions variable.

PLATE 64. *World Toy Packages, Hero,* 1981, TV image and mirror, photostat, mirror, paper, plastic, type, 7"x5"x1".

PLATE 65. *World Toy Packages, Be a Little Devil Adult Toy",* 1981, cardboard tongue teaser, photostat, paper, plastic, type, 7"x5"x1".

PLATE 66. *World Toy Packages, Danger Radiation,* 1981, cigarette butts, artificial sugar, cat fur, photostat, paper, plastic, type, 7"x5"x1".

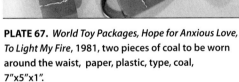

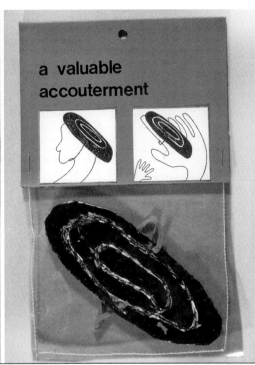

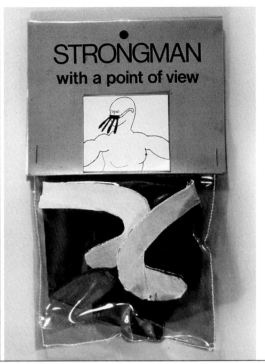

PLATE 67. *World Toy Packages, Hope for Anxious Love, To Light My Fire*, 1981, two pieces of coal to be worn around the waist, paper, plastic, type, coal, 7"x5"x1".

PLATE 68. *A Valuable Accoutrement,* 1981, depending on the elasticity of the rubber band, one dual function cardboard hat-ring, photostat, paper, acrylic, plastic, type, 7"x5"x1".

PLATE 69. *Strong Man with a Point of View,* 1981, cardboard face protrusion, photostat, paper, plastic, acrylic, type, 7"x5"x1".

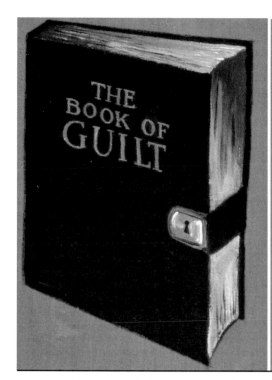 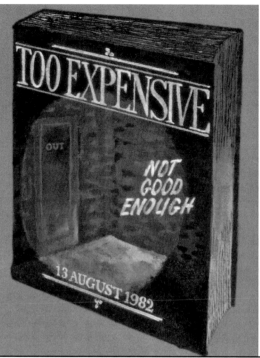 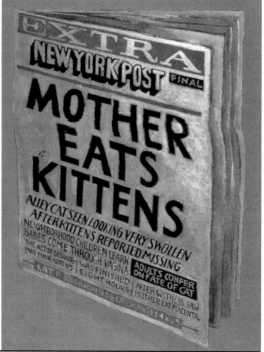

PLATE 70 *Pulp Fiction, The Book of Guilt,* 1982, acrylic on canvas, 12"x8".

PLATE 71 *Too Expensive, Not Good Enough,* 1982, acrylic on canvas, 12"x8".

PLATE 72 *Pulp Fiction, Mother Eats Kittens,* 1982, Alley cat seen looking very swollen after kittens reported missing. Neighborhood children learn babies come through vagina. Act of devouring four kittens was finished eight hours after witness saw mother eat placenta. acrylic on canvas,12"x8".

96]

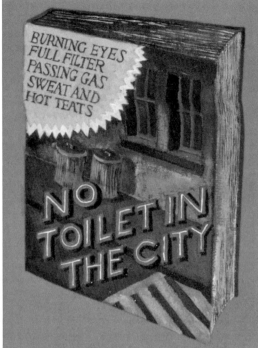

PLATE 73. *Pulp Fiction, Lais-sez Faire Philosophy*, 1982, acrylic on canvas, 12"x 8".

PLATE 74. *Pulp Fiction, Burning Eyes, Full Filter, Passing Gas, Sweat and Hot Teats, No Toilet in the City*, 1982, acrylic on canvas, 12"x 8".

PLATE 75. *Flat for the Illiterate, No Nonsense Braille to See*, 1982, acrylic on canvas, 12"x 8".

PLATE 76. *Pulp Fiction, What's in a Cats Eye,* 1982, acrylic on canvas, 12"x 8".

PLATE 77. *Pulp Fiction, A Picture is Worth a Thousand Words,* 1982, acrylic on canvas, 12"x8".

PLATE 78. *The Future of Painting,* 1982, acrylic and photo of calculator on canvas, 12"x8".

PLATE 79. *Art For Sale*, 1983, wood, paper, tin, artist, Benefit for The New Museum, dimensions variable.

PLATE 80. *Food For Sale, Push Carts*, 1979, Central Park, photos, 5"x7".

PLATE 81. *Burghers of Calais,* Auguste Rodin, 1884-1886, Bronze, 82 1/2"x94"x95 ", The Metropolitan Museum of Art.

PLATE 82 . *The Battle between Christians and Moors at El Sotillo*, Francisco de Zurbarán, ca. 1637-1639, oil on canvas, 131 7/8"x75 1/4", The Metropolitan Museum of Art.

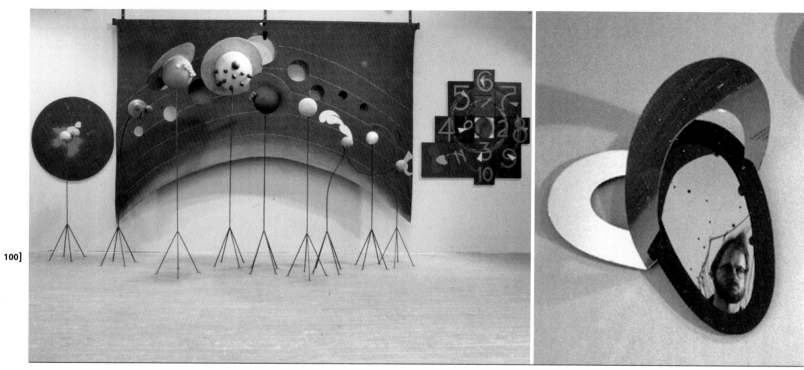

PLATE 83. *When What Place, Black Hole, Hello Hello, Twirl of Time, Clock of Paintings Sunshine,* 1984, installation view, wood, metal, oil paint, light, megaphone, clocks, dimensions variable.

PLATE 84. *When What Place, Altogether Our Time You and the Universe Passing A Place*, 1984, wood, plastic, clock, dimensions variable.

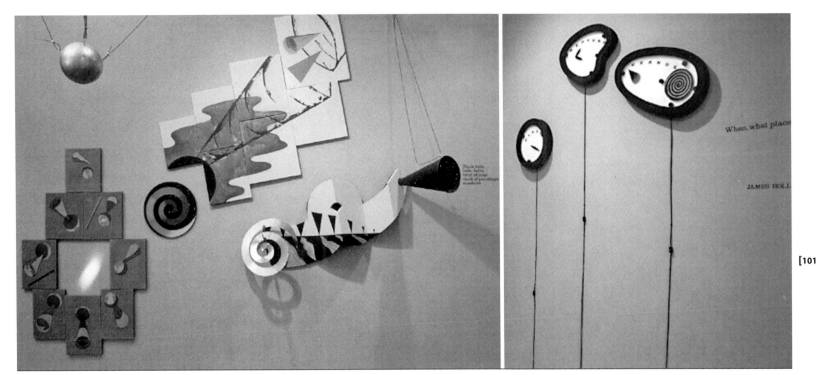

PLATES 85 AND 86. *When What Place, Black Hole, Hello Hello, Twirl of Time, Clock of Paintings Sunshine*, 1984, installation view, wood, metal, oil paint, light, megaphone, clocks, dimensions variable.

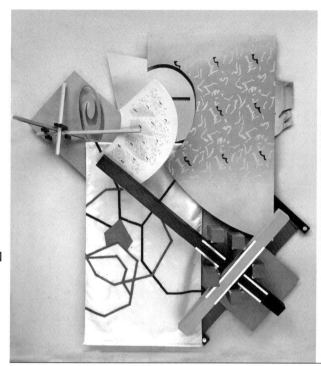

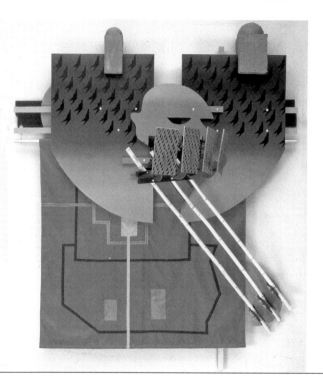

PLATE 87. *"Dealer Shows His Hand, Russia,* 1986, wood, metal, oil paint, nylon, acrylic, 60"x60"x20".

PLATE 88. *Dealer Shows His Hand, China,* 1986, wood, metal, oil paint, nylon, acrylic, 60"x60"x20".

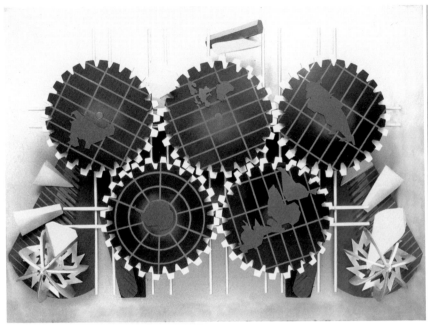

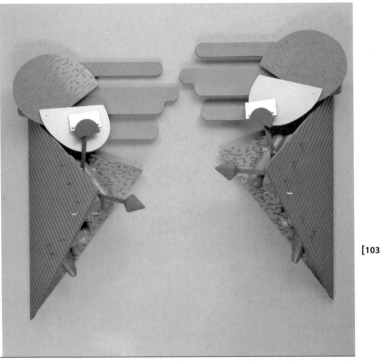

PLATE 89. *How The World Turns,* 1986, wood, metal, oil paint, acrylic, 60"x96"x16".

PLATE 90. *Close Shave for Both of Us,* 1986, wood, metal, oil paint, acrylic, 48"x56"x12".

PLATE 91. *Passing Times,* 1986, wood, spray paint, marble resin casts, lights, electricity, clocks, cast plastic, 50"x132"x18".

PLATE 92. *Passing Times,* 1986, wood, spray paint, marble resin casts, lights, electricity, clocks, cast plastic, 50"x132"x18".

PLATE 93. *Figments With a Pause,* 1987, fiberglass, glass, light, oil paint, steel, 40"x60"x20".

PLATE 94. *Figments With Pause,* 1987, fiberglass, glass, light, oil paint, steel, 40"x60"x20".

PLATE 95. *Figments, Brain in Space,* detail 1987, fiberglass, glass, light, oil paint, steel, 40"x60"x20".

PLATE 96. *Figments, by Calculations,* detail 1987, fiberglass, glass, light, oil paint, steel, 40"x 60"x20".

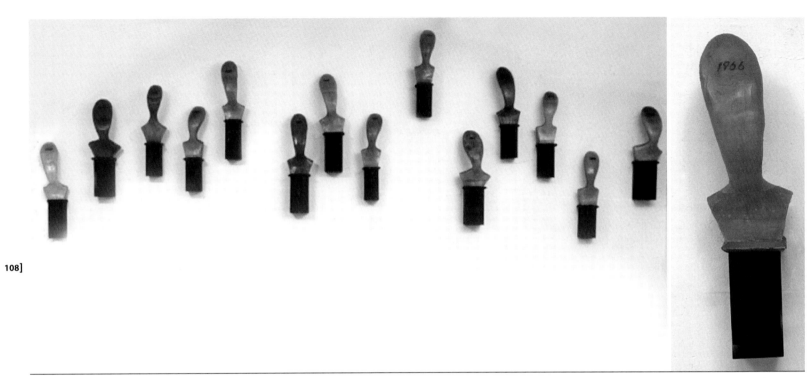

PLATE 97. *Century of Busts,* 1990, wax, wood, dimensions variable.

PLATE 98. *Century of Busts,* 1990, wax, wood, 25"x6"x6".

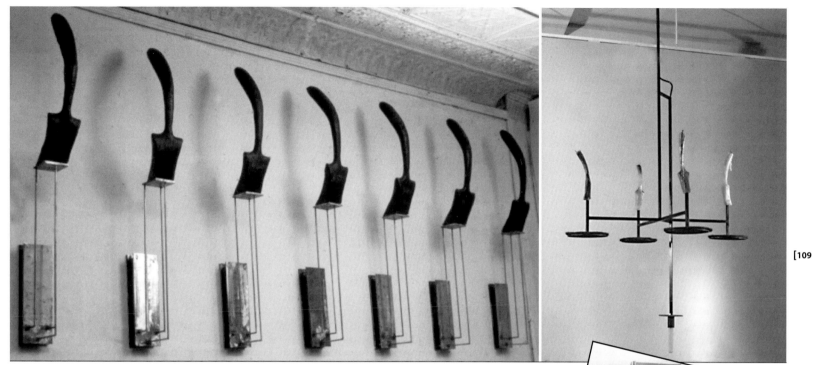

PLATE 99. *When Alive We're Ahead Once Dead We're...*, 1991, wax, steel, dimensions variable.

PLATE 100. *Poets Candelabra, with Poets Content Box,* 1991,
pine, plaster, stain, lead, 84"x34"x34".

PLATE 101. *Couple's Coat Hanger at 3 am,* 1991, a functional coat hanger hosting busts of mates who have committed to share commemorating rings, steel, brass, poplar, stain, 36"x48"x12".

PLATE 102. *Forms of Allusion,* 1991, installation view, steel, brass, poplar, wool, lead, dimensions variable.

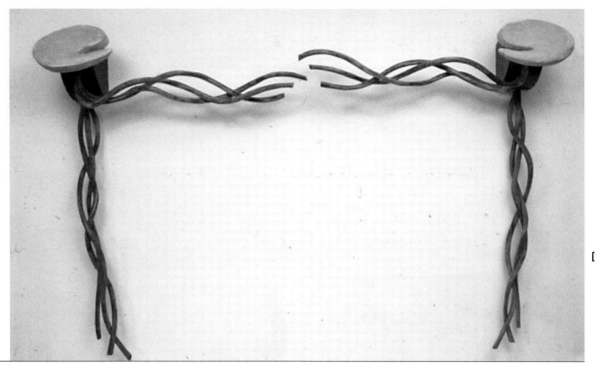

PLATE 103. *Yearning Couple at 3 am,* 1991, poplar, stain, plaster, lead, wax, 72"x120"x12".

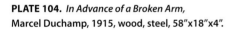

PLATE 104. *In Advance of a Broken Arm,*
Marcel Duchamp, 1915, wood, steel, 58"x18"x4".

PLATE 105. *In Advance of a Swept Room,* 1991,
poplar, wire, 55"x30"x9".

PLATE 106. *The Yoke of Generations,* 1992, a generation's genes burn to a single candle, the last candle is you to burn, poplar, wax, candle, 72"x36"x6".

PLATE 107. *The question is bigger than the key,* 1991, **a** proposition of scale, the key to the big question is smaller than the lock, poplar, 60"x10"x6".

PLATES 108, 109, 110. *Votive Stands,* 1991, offerings of fruit from the earth, functional and associative to an undetermined
primitive earth appreciation ceremony, the offerings can be eaten by the viewers, a commentary on the consumption
of art, poplar wood, canvas, vegetables, 48"x10"x10".

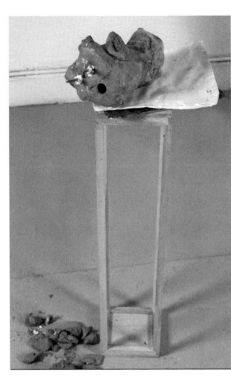

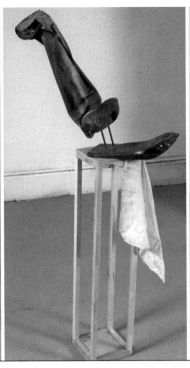

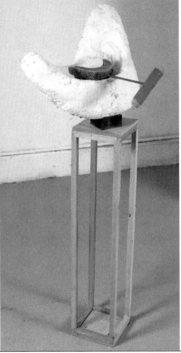

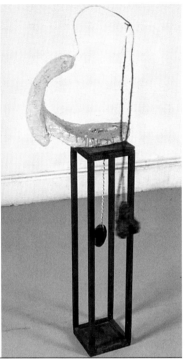

PLATE 111. *Jack's Dissolution,* 1993, wood, clay, plaster, 40"x12"x12".

PLATE 112. *Marina,* 1993, wood, wax, cloth, 40"x12"x18".

PLATE 113. *Self Portrait Smiling,* 1993, wood, plaster, lead, 36"x16"x16".

PLATE 114. *Ashley,* 1993, wood, plaster, steel, wax, 48"x18"x16".

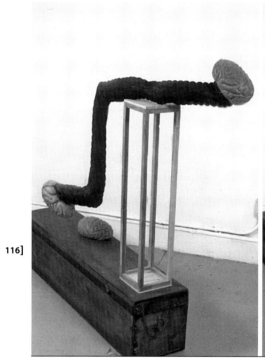

PLATE 115. *Robert's Many Brains,*1993, wood, wax, 48"x10"x56".

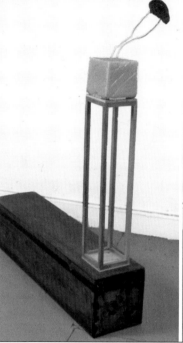

PLATE 116. *Susan with Far Away Ear,* 1993, wood, wax, steel, 40"x12"x56".

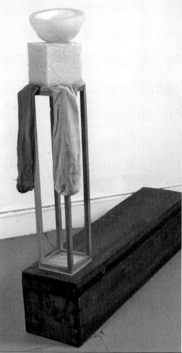

PLATE 117. *Carol with pockets,* 1993, wood, wax, dimensions 48"x10"x56".

PLATE 118. *Carol Variation With Bird Peering into Her Head,* 1993, wood, plaster, cloth, 40"x12"x12".

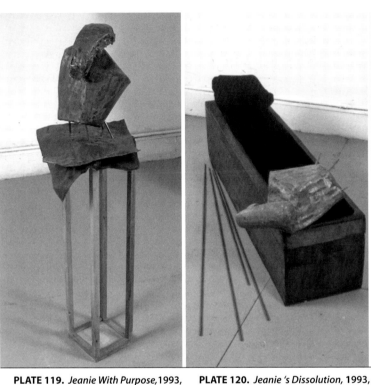

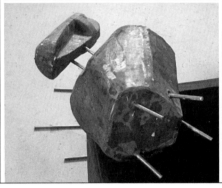

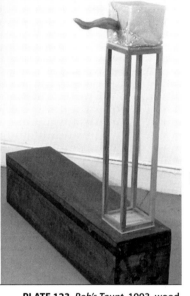

PLATE 119. *Jeanie With Purpose,* 1993, wood, lead, 40"x12"x12".

PLATE 120. *Jeanie 's Dissolution,* 1993, wood, lead, 12"x10"x56".

PLATE 121. Above, *Rob's Taunt*, detail.
PLATE 122. Below, *Jeanie*, detail.

PLATE 123. *Rob's Taunt,* 1993, wood, wax, 48"x10"x56".

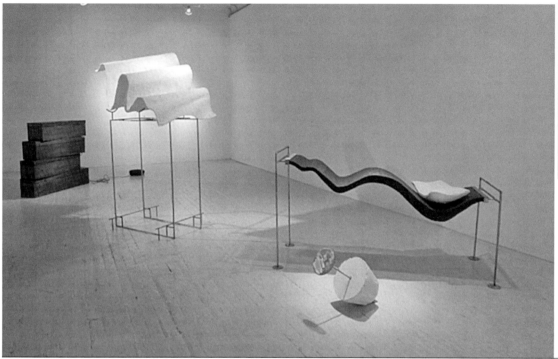

PLATE 124. *Our Last Sleep We Fly,* 1994, installation view, steel, wool, wax, wood, flowers, fiberglass, rope, paint, plastic and plaster, oil paint on canvas, dimensions variable.

PLATE 125. *Our Last Sleep We Fly*, 1994, installation view, steel, wool, wax, wood, flowers, fiberglass, rope, paint, plastic and plaster, oil paint on canvas, dimensions variable.

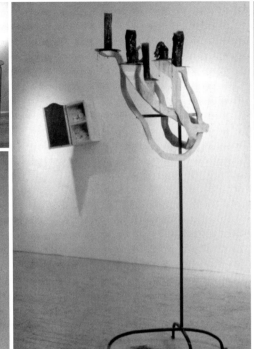

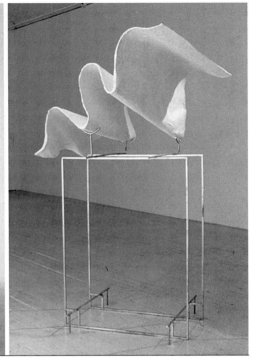

PLATE 126. *Waiting Room*, 1994, steel, flowers, 60"x48"x16".

PLATE 127. *Thrown lamp*, 1994, steel, plaster, 21"x12"x16".

PLATE 128. *Have solace,* 1994, steel, plaster, 21"x12"x16".

PLATE 129. *Tossed cover,* 1994, steel, plaster, fiberglass, 72"x60"x36".

ENDNOTES

1. Stanley Kauffman, "Books and the Arts," *The New Republic*, 11.20.06, 27.
2. Jack Burnham, Ad Reinhardt, *Great Western Salt Works*, George Braziller, 1974, 1.
3. Mark Epstein, MD, *Thoughts Without a Thinker*, Basic Books, 1995, 33.
4. Adrienne Baxter Bell, *George Inness and the Visonary Landscape*, National Academy of Design, 2003, 37.
5. Ursula Meyer, *Conceptual Art*, E.P. Dutton, 1972; Lucy Lippard, *Six Years: The Dematerialization of the Art Object*, Praeger, 1973.
6. Ibid., 34.
7. Ibid., 152.
8. Octavio Paz, *Marcel Duchamp*, Arcade, 1978, 16.
9. Burnham, 71; and Hans Richter, *Dada, Art and Anti-art*, Thames & Hudson World of Art, 1964, 89.
10. George Kubler, *The Shape of Time*, Yale University Press, 1962, 54.
11. Ibid., 67.
12. Richter, 12.
13. Ibid., 35.
14. Ibid., 76.
15. Ibid., 34.
16. Ibid., 65.
17. Ibid., 67.
18. Ibid., 48.
19. Ibid., 51.
20. Ibid., 55.
21. Ibid., 55.
22. Ibid., 55.
23. Ibid., 57.
24. Ibid., 60.
25. Ibid., 171.
26. Ibid., 91.
27. Ibid., 205.
28. Ibid., 206.
29. Ibid., 206.
30. Ibid., 208.
31. Ibid., 208.
32. Brian O'Doherty, "Art Review," *New York Times*, 10/31/63, page unknown.
33. Ibid., 208.
34. Ibid., 210.
35. Thomas McEvilley, *The Triumph of Anti-Art Conceptual and Performance Art in the Formation of Post Modernism*, (Documentext, 2005), 64.
36. Ibid., 67.
37. Ibid., 236.
38. Ibid., 236.
39. Ibid., 64.
40. Charles Harrison, Paul Wood, *Art in Theory*, Blackwell, 1994, 573.
41. Kay Larson, "On The Beach," *New York Times*, 9.5.83, 53.
42. Grace Glueck, "Gallery View," *New York Times*, 6.31.83, 25.
43. Ken Johnson, "Shoot it Yourself," *New York Times*, 2.29.08, 34.
44 Arthur Danto, *Beyond the Brillo Box*, University of California Press, 1992, 4.
45. Ibid., 157.
46. Ibid., 6.
47. Ibid., 5.
48. Ibid., 8.
49. Ibid., 40.
50. Ibid., 9.
51. Ibid.,124.
52. Michael Kammen, *Visual Shock*, Knopf, 2006, 52.
53. Ibid., 53.
54. Ibid., 72.
55. Ibid., 316.
56. McEvilley, 239.
57. Ibid., 239.
58. Frederick Ante, *Classicism and Romanticism*, Icon Editions, 1973, 33.
59. Matthew Collings, *Modern Painters*, April, 2007, 34.
60. John P. O'Neill, *Barnett Newman, Selected Writings and Interviews*, University of California Press, 140.
61. Ibid., 145.
62. Ann Temkin, *Barnett Newman*, Yale University Press, 2002, 81.
63. Victor Brockris, *Life and Death of Andy Warhol*, Bantam, 1989, 197.
64 Collings, 34.
65. Ibid., 36.
66. John Sturrock, *Structualism and Since*, Oxford University Press, 1979, 7.
67. Danto, 10.
68. Robert C. Morgan, *The End of the Art World*, Allsworth Press, 1998, 5.
69. O'Neill, 151.
70. Morgan, 178.
71. Burnham, 139.
72. McEvilley, 64.
73. Meyer, 34.
74. Kubler, 16.
75. Ibid., 66.
76. Roger Scruton, *Kant, A Very Short Intrtoduction*, Oxford, 2001, 34.
77. Brian Breen, "The Orgins of the Universe: A Crash Course," *The New York Times*, 9.12.08, 23.
78. Scruton, 100.
79. Ibid.,105.

80. Ibid., 107.

81. Ibid., 35.

82. Ibid., 36.

83. Dennis Overbye, "Big Brain Theory, Have Cosmologists Lost Theirs?," *Science Times, The New York Times*, 1.15.08, F1.

84. Ibid., F1.

85. Ibid., F1.

86. Jill Bolte Taylor, Ph. D., *My Stroke of Insight, A Brain Scientist's Personal Journey*, Viking Press, 2006, 20.

87. Ibid., 69.

88. Ibid., 19.

89. Ibid., 134.

90. Ibid., 13.

91. Ann Minard, "Down Canyons and Up Cliffs, Pursuing Sourthwest's Ancient Art, " *The New York Times*, 9.9.08, F3.

BIBLIOGRAPHY

Ante, Frederick. *Classicism and Romanticism*. New York: Icon Editions, Harper and Row, Publishers, 1973.

Bell, Adrienne Baxter. *George Inness and the Visionary Landscape*. New York: National Academy of Design, 2003.

Bolte, Jill, Ph.D. *My Stroke of Insight, A Brain Scientist's Personal Journey*. New York: Viking, 2006.

Brockris, Victor. *Life and Death of Andy Warhol*. New York: Bantam Books, 1989.

Burnham, Jack. *Great Western Salt Works*. New York: George Braziller, 1974.

Collings, Matthew. "What I Do All Day." *Modern Painters*, April 2007: 34-37.

Danto, Arthur. *Beyond the Brillo Box*. Berkeley: University of California Press, 1992.

Epstein, Mark, MD. *Thoughts Without a Thinker*. New York: Basic Books, 1995.

Glueck, Grace. "Gallery View, Engaging Experiments Transform a Sandy Site." *New York Times,* 31 July 1983: 25, Arts and Leisure Section.

Harrison, Charles, and Wood, Paul. *Art in Theory 1900-1990*. Cambridge: Blackwell Publishers, 1992.

Johnson, Ken. "Shoot it Yourself," *The New York Times,* Februrary 29, 2008: E31.

Kammen, Michael. *Visual Shock*. New York City: Knopf, 2006.

Kauffman, Stanley. "Books and the Arts." *The New Republic,* November 20, 2006, 20-27.

Kubler, George. *The Shape of Time*. New Haven and London: Yale University Press, 1962.

Larson, Kay. "On The Beach." *The New York Magazine,* September 5, 1983: 52, 53.

Lippard, Lucy. *Six Years: The Dematerialization of the Art Object*.

New York: Praeger, 1973.

Meyer, Ursula. *Conceptual Art*. New York: E.P. Dutton, 1972.

Minard, Anne. "Down Canyons and Up Cliffs, Pursuing Southwest's Ancient Art," *The New York Times*. September, 9, 2008: F3.

McEvilley, Thomas. *The Triumph of Anti-Art Conceptual and Performance Art in the Formation of Post Modernism*. Kingston, New York: Documetext, 2005.

Morgan, Robert C. *The End of the Art World*. New York: Allsworth Press, 1998.

O'Doherty, Brian. "Art Review." *The New York Times,* 31 Oct. 1963, page unknown.

O'Neill, John P, and Mollie McNickle. *Selected Writings and Interviews*. New York: Alfred A. Knopf, 1990.

Overbye, Dennis. "Big Brain Theory, Have Cosmologists Lost Theirs?" *The New York Times,* January 2008: F1, F4.

Paz, Octavio. *Marcel Duchamp Appearance Stripped Bare*. New York: Arcade Publishing, 1978.

Richter, Hans. *Dada, Art and Anti-art*. Singapore: Thames & Hudson World of Art, 1965.

Scruton, Roger. *Kant, A Very Short Introduction*. Oxford: Oxford University Press, 2001.

Sturrock, John. *Structuralism and Since*. Oxford: Oxford University Press, 1979.

Temkin, Ann. *Barnett Newman,* Philadelphia: Philadelphia Museum of Art, 2002.

Thompson, Mel. *Teach Yourself Ethics. London*: Hodder Education, 1994.

Turn a Line on its End and it's a Dot, 1999, acrylic on paper, 20"x20".

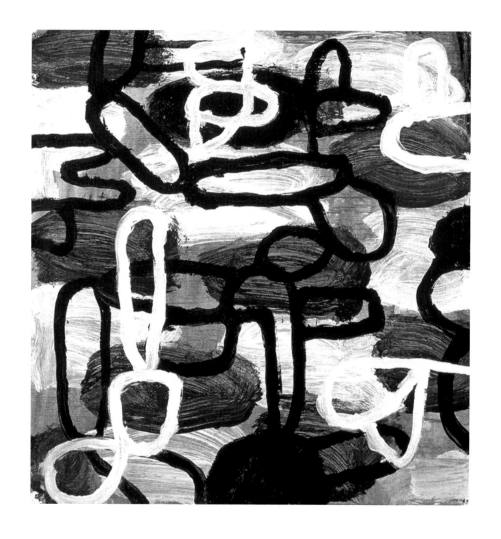

Is That all There Is, 2000, acrylic on paper, 20"x20".

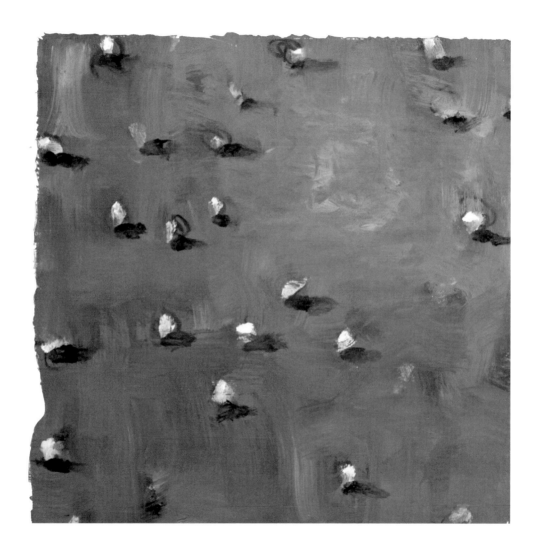

Indeterminate Landscape, September 12, 2001, 2001, oil on panel, 60"x60".

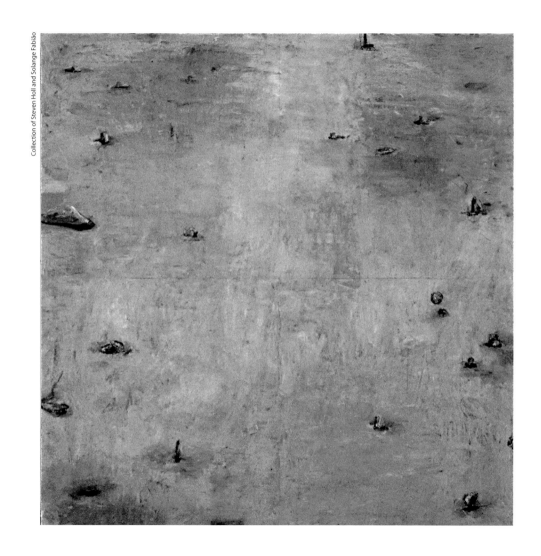

To find out more about Charta,

and to learn about our most recent publications, visit www.chartaartbooks.it

Printed in July 2009 by Leva spa, Sesto San Giovanni, for Edizioni Charta